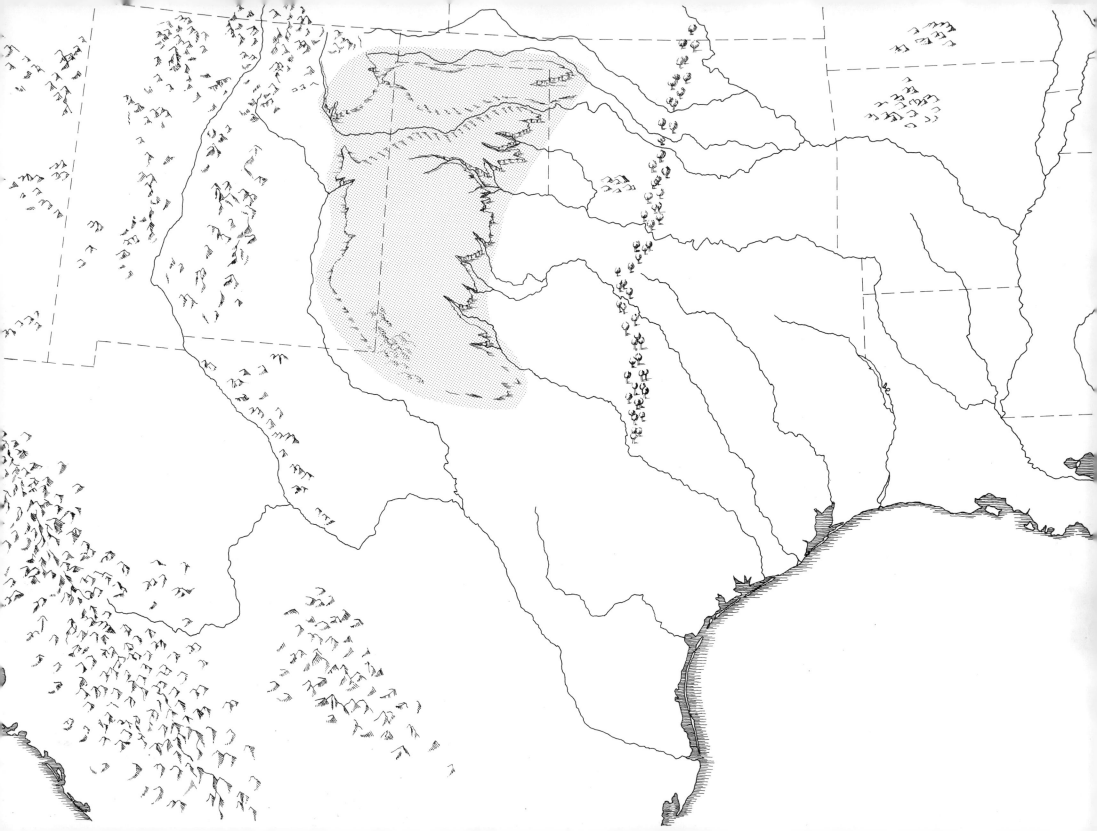

CANYON

VISIONS

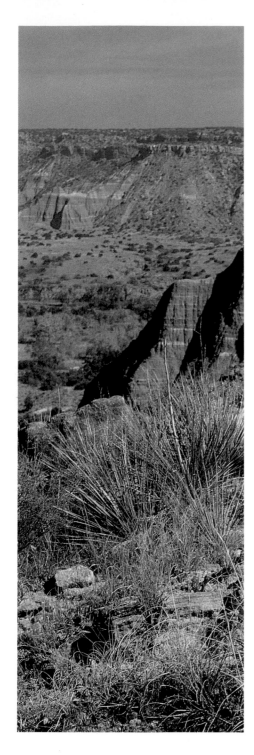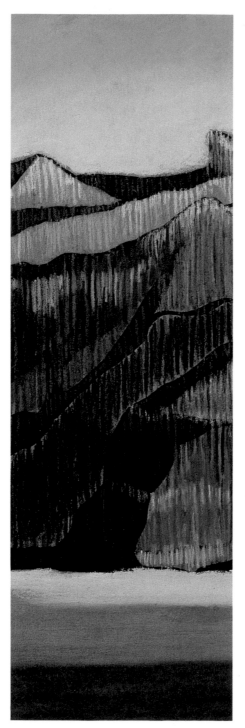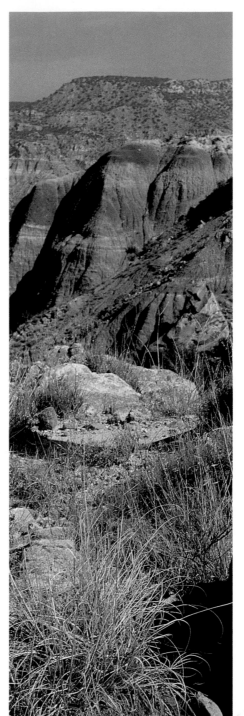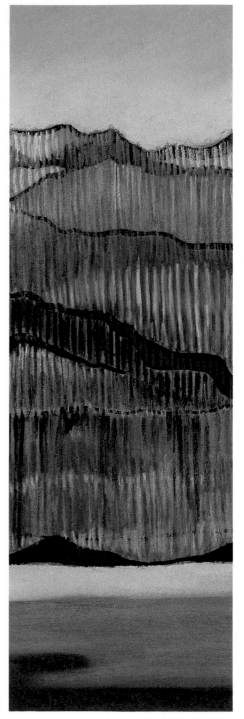

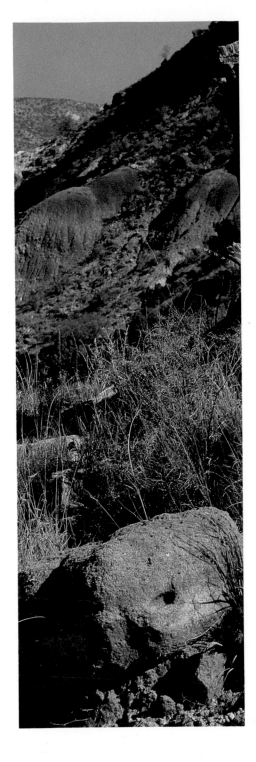

CANYON
VISIONS

Photographs and Pastels
of the Texas Plains

Photographs by Dan Flores

Pastels by Amy Gormley Winton

Text by Dan Flores and Amy Gormley Winton

Foreword by Larry McMurtry

TEXAS TECH UNIVERSITY PRESS

LUBBOCK

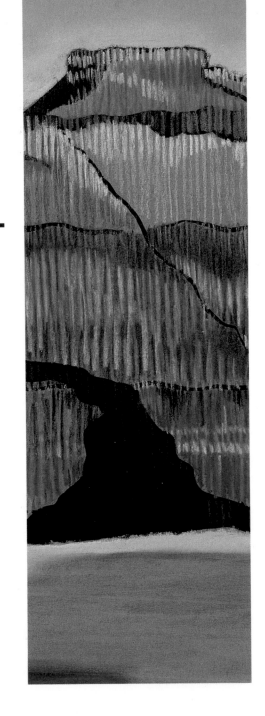

ACKNOWLEDGMENTS

The authors wish gratefully to acknowledge Dean Eric Bolen of the University of North Carolina-Wilmington for the generous loan to us of his large format camera equipment, and Jim Freeman and Lisa Douglas of Amarillo, who photographed the pastel paintings.

This book was set in 12 on 15 Garamond and printed on acid-free paper that meets the guidelines for permanence and durability of the Committee on Production Guidelines for Book Longevity of the Council on Library Resources. ∞

Jacket and book design by Joanna Hill.

Library of Congress Cataloging-in-Publication Data

Flores, Dan L. (Dan Louie), 1948–
 Canyon visions: photographs and pastels of the Texas Plains /
photographs by Dan Flores ; pastels by Amy Gormley Winton ; text by
Dan Flores and Amy Gormley Winton.
 p. cm.
 Includes indexes.
 ISBN 0-89672-193-0 (alk. paper). — ISBN 0-89672-194-9 (pbk. :
alk. paper)
 1. Canyons—Llano Estacado—Pictorial works. 2. Canyons—Texas
Panhandle (Tex.)—Pictorial works. 3. Llano Estacado—Description
and travel—Views. 4. Texas Panhandle (Tex.)—Description and
travel—1981—Views. I. Winton, Amy Gormley. II. Title.
F392.L62F56 1989
976.4'8'00222—dc20 89-4982
 CIP

Texas Tech University Press
Lubbock, Texas 79409-1037 USA

Manufactured in Japan by Dai Nippon Co., Ltd.

This book is dedicated to hoodoos, canyon wrens, and red Dockum sandstone.

FOREWORD

A LAND BELOW
THE PLAIN

In his graceful and perceptive introduction to this book, Dan Flores points out that many—probably most—travelers across the Southern Plains never really consider looking below those plains. People who have lived in West Texas all their lives often merely move back and forth along the main-traveled roads; they have no inkling that canyon visions possessing both delicacy and majesty are there to be seen and wondered at, often only a few miles from their long-familiar routes.

This book may make many people canyon-lookers. Amy Gormley Winton's sensitive, subtle pastels and Dan Flores's strong photographs will introduce many readers to a little-visited but compelling world, just below the prairie's eastern rim.

I first saw this world in my boyhood, through the accident of having several uncles who ranched in the counties where these canyons lie. They are very individual, each with a character that cannot be instantly apprehended; one has to look for a while, and look carefully, as Flores and Winton have done.

None of these canyons will produce in the visitor the level of awe that the Grand Canyon of the Colorado often awakens; nor do they have the immediate heart-stopping beauty of the Canyon de Chelly, to my mind the most striking of the holy canyons of the Anasazi peoples.

What the canyons below the Caprock have is more intimate and more subtle; Flores's camera and Winton's pastels have captured their intimacy, as well as the canyon's tendency to sweep the eye suddenly upward to the great sky. It may be that the mountain visions that have dominated so much American landscape art for so long are essentially masculine; and canyons, on the other hand, essentially female, portals to mother earth. It may be so; and it may be also unimportant.

What is undeniable, and well rendered here, is the power that these canyons have to arouse in us a sense of the long, long movements of time—a sense, if you will, of the eternal.

—LARRY McMURTRY

CONTENTS

Foreword / vii

Introduction / 1

Elements / 5

Form / 23

Texture / 47

Color / 63

Light / 87

Sources of Historical Quotations / 109

Indexes / 110

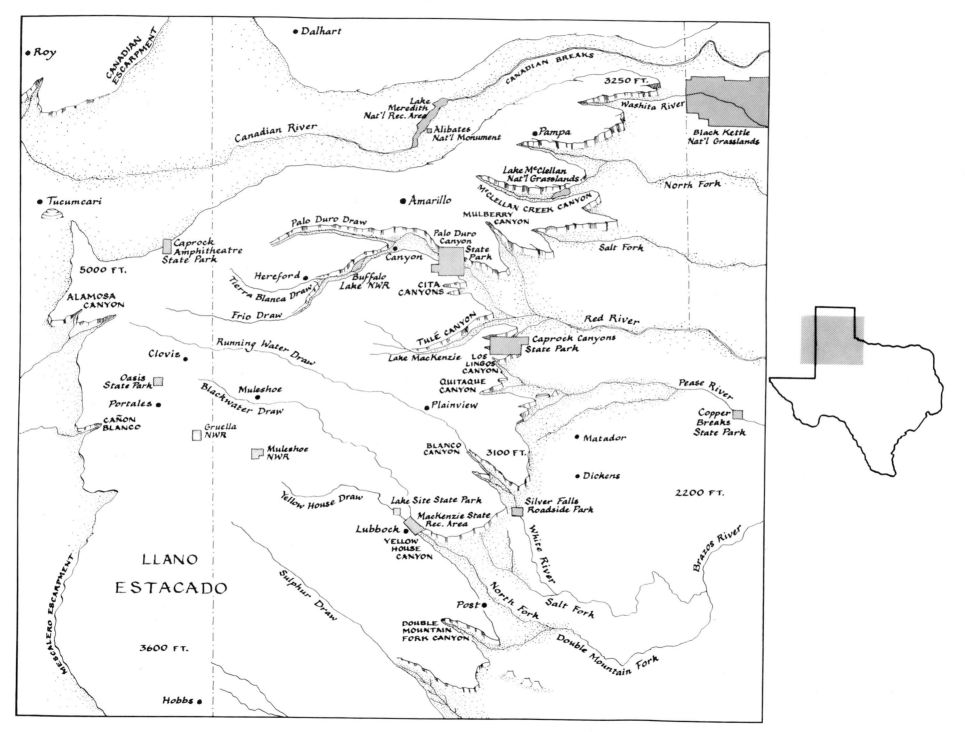

• Roy

CANADIAN ESCARPMENT

• Dalhart

CANADIAN BREAKS

3250 FT.

Washita River

Canadian River

Lake Meredith Nat'l Rec. Area

Alibates Nat'l Monument

• Pampa

Black Kettle Nat'l Grasslands

North Fork

Lake McClellan Nat'l Grasslands

• Tucumcari

• Amarillo

McCLELLAN CREEK CANYON

MULBERRY CANYON

Salt Fork

Palo Duro Draw

Palo Duro Canyon State Park

5000 FT.

Caprock Amphitheatre State Park

• Canyon

ALAMOSA CANYON

Hereford •

Buffalo Lake NWR

CITA CANYONS

Tierra Blanca Draw

Red River

Frio Draw

THLÉ CANYON

Running Water Draw

Lake MacKenzie

Caprock Canyons State Park

• Clovis

LOS LINGOS CANYON

Oasis State Park

QUITAQUE CANYON

Pease River

• Muleshoe

Blackwater Draw

• Plainview

Portales •

Copper Breaks State Park

CAÑON BLANCO

Gruella NWR

Muleshoe NWR

BLANCO CANYON

3100 FT.

• Matador

• Dickens

2200 FT.

Yellow House Draw

Lake Site State Park

Silver Falls Roadside Park

MacKenzie State Rec. Area

Lubbock •

White River

YELLOW HOUSE CANYON

LLANO

ESTACADO

Sulphur Draw

North Fork

Salt Fork

Brazos River

• Post

MESCALERO ESCARPMENT

DOUBLE MOUNTAIN FORK CANYON

Double Mountain Fork

3600 FT.

Hobbs •

MAP BY DAN FLORES AND AMY TROYANSKY

INTRODUCTION

How one sees nature depends on how one defines words such as *landscape, wild,* and *natural.* And these definitions spring from culture as surely as do the choices we make in cuisine, music, art, or literature. All of us are shaped from birth—through the ordinary events of our everyday lives, the popular culture to which we are exposed through various media, the high culture of our formal educations—by a sensory and intellectual milieu that surrounds us like an ocean. Like any species evolving in response to its environment, we see in nature what we're conditioned to see, what our cultural experiences have prepared us to believe is worthy of attention, important. So the human perception of nature, of regional landscapes and their significance, changes over time.

A good example of this can be found in how landscape artists have seen the Texas plains over the span of the last century and a half. Lithographs from the early explorations of the plains canyonlands in the 1840s and 1850s portray the angular cliffs and sculpted badlands as Old World ruins, consistent with the artistic convention of the early American Romantic Age, which yearned for stunning natural scenes that might compare favorably with Europe's historical architecture. Half a century later, when Americans were becoming aware that their expansionist successes were jeopardizing even Western wilderness, Frank Reaugh painted thousands of tiny pastel landscapes of the plains whose raison d'etre seems to have been, in part, a Romantic wish to preserve images of the unsullied and the great unfenced. A young Georgia O'Keeffe celebrated the plains and its

canyonlands as a magical world of extraordinary color and simple, powerful landforms, whose human artifacts were tacked on almost as an afterthought, hardly real and unworthy of attention against such a landscape. And Alexandre Hogue, painting the Texas plains when the frenzy of homesteading and plowing had combined with drought to produce the Dust Bowl, "saw" with an ecological conscience and painted an Earth Mother stripped bare by raping plows, her beauty and sensuality despoiled by fences and powerlines. Each of these artists saw the same landscape, the same coloring and geology. And they all responded differently.

The visual images of the Texas plains that appear here are no less ordered by cultural preparation, but because the shaping influences of our time are different from those that moved an O'Keeffe or a Reaugh, perhaps these visions represent another and different bead on the string of that continuum. Not that our own visions are identical. But they are similar, and one of the similarities, evident from the subject of this book, is a certain fascination with the borders of the West Texas plains, with the escarpment edges where canyons and badlands, erosional phenomena such as hoodoos and pedestal rocks, and coyotes and mule deer still sing what Mari Sandoz once called the Song of the Plains. The great horizontal yellow of the Llano Estacado once possessed an unparalleled power to lift the human mind to questions of scale and infinity and the relationship of the individual to nature. Traveling across the Llano Estacado in 1832, mountain man (and later poet and judge) Albert Pike wrote that "the sea, the woods,

the mountains, all suffer in comparison with the prairie. . . . The prairie has a stronger hold upon the senses. Its sublimity arises from its unbounded extent, its barren monotony and desolation, its still, unmoved, calm, stern, almost self-confident grandeur, its strange power of deception, its want of echo, and, in fine, its power of throwing a man back upon himself."

That magic has mostly disappeared from the horizon-to-horizon croplands of the late twentieth-century Llano, although if the future of Southern Plains agriculture is what many of us suspect, much of the High Plains may someday repossess itself of this old power. But today the wild and natural are mostly vanquished from the vast flats, which are plowed and shaped into rectangles and squares and circles of cotton, wheat, and sorghum. With statistics showing that the counties surrounding Lubbock for fifty miles retain at present only three percent natural vegetation, anyone with a certain longing for the natural will see why the images in this book are taken largely from below the Llano.

For a species whose evolution was shaped so much by a plains setting, we humans—especially we Americans—have never found much to admire in plains country other than skies. This is another aspect of our cultural preparation; since the time of Thomas Jefferson, scenery for Americans has meant mountains. The mountain aesthetic shaped our national tastes in the nineteenth-century, when the Hudson River and Rocky Mountain schools of painting instructed us in how to differentiate among beautiful, picturesque, and sublime landscapes. And in the twentieth-century, the National Park Service made monumentalism, in the form of great mountains, canyons, and waterfalls, into a kind of nature religion cum tourism. European observers have noticed the role nature plays in our regional and national sense of ourselves for more than a century, and

they are still commenting on it. In a recent issue of *Landscape*, a 1980s British visitor expressed surprise that so few Americans brag about the Chicago skyline or the shops and restaurants in Manhattan. Instead, Americans told him to see the Grand Canyon, experience the Rockies, visit Yosemite.

This discourages plains people. They look around them at the smooth line of the horizon, see no mountains in any direction, and accept the widespread consensus that the region is unlovely and, perhaps, not much worthy of love. It is a perception that would seem to be validated by the relative scarcity of park and wilderness lands on the plains, and particularly the Southern Plains.

Even the paucity of park lands on the plains has cultural explanations if one happens to know the story of public lands in Texas history, but the lack of remarkable scenery on the plains is not one of them. This seeming conundrum is apparent to anyone who has seen the Llano Estacado from the air: the dramatic landscapes of the Texas plains do not stand as mountains above the horizon line and in obvious view; they lie below the Llano in the form of badlands and breaks and sharply etched canyons from which several of the famous trans-Texas rivers take their headwaters. The vast majority of people who cross the Southern Plains by automobile and even most of those who live here seldom see this scenery; because it lies below rather than above the horizon line, for them it doesn't exist. There is a danger that this view is becoming the cultural preparation for a modern response to the plains. And without the landscape, without the wild, without awe for the natural, the sense of the very real biological and mythological ties between humans and earth withers. The meaning of landscape is inevitably reduced to commodities futures and dollar signs when the land surrounding one in all directions seems to have had the wild soul ripped out of it.

The cultural preparation behind the two perspectives that color these visual images has roots, as most likely will be apparent, in the Romantic conception of nature as a spiritual well for those who have been desensitized by modern, civilized living; in the Native American idea of nature as sacred and mythological space; and in an ecological commitment to the wild—the diverse, unspoiled, harsh beauty of wilderness. Once seen by American culture as almost useless wastes, desert canyonlands have come to stand, since the time of Mary Austin and John C. Van Dyke, as icons for the elemental nature power of the American Southwest. In the canyons at the origins of the Colorado, Brazos, and Red Rivers there is much that is spiritual, sacred, and wild. The Comanches and Kiowas knew this long before George Wilkins Kendall or Randolph Marcy tried to describe it, or Georgia O'Keeffe attempted to capture it in watercolor and oil.

And the old power is still there, despite changes in the land since the Comanches owned it. The canyons are rather less pristine today (although they were never "virgin," at least not since men and women began living in them more than 12,000 years ago), but vast stretches of them are still wild, in the modern definition, and roadless, and if they weren't in Texas, large parts of these canyonlands would already be national parks and monuments and nature preserves of various kinds. Unlike the rest of the American West, most of the Great Plains—especially those in Texas—were privatized, making public access almost impossible and public lands dedicated to preserving the plains wilderness pathetically sparse. At present, there are approximately 150,000 acres of Texas High Plains in the national grassland system, lands acquired by the federal government as a result of Dust Bowl failures and now administered primarily for grazing by the Forest Service. Lake Meredith National Recreation Area and the Alibates Flint Quarry National Monument preserve small but significant sites in the Canadian Breaks. A trio of national wildlife refuges, separated widely from one another, exists on the Texas High Plains. But in the canyonlands, just two state parks, Palo Duro Canyon State Park south of Amarillo in Randall County and the new Caprock Canyons State Park in Briscoe County, protect a paltry 29,000 acres of (mostly) wild terrain. A third park is planned for the Lubbock area, possibly in Blanco Canyon, one of the beautiful grassland canyons at the head of the Brazos. If lightly developed like Caprock Canyons, such a park would increase the diversity of wilderness in the Llano Estacado country.

This scarcity of protected wilderness would be even more difficult to accept if it were widely known that in the 1930s the National Park Service considered building a one-million-acre National Park of the Plains around Palo Duro and Tule canyons; and that a 135,000-acre national monument (which would have become a greatly enlarged national park as a result of the Omnibus Park Bill of 1978) in Palo Duro was in the offing in 1938, had the heroic efforts of people such as Guy Carlander and J. Evetts Haley, Hattie Anderson and Phebe Warner succeeded. But Texas never raised the money to acquire the land. In ways that are hard to gauge, nature awareness on the Texas plains has suffered as a result of the region's failure to acquire a large and significant national park. But simple things such as biological and cultural familiarity with, and public access to, some of the most spectacular and scientifically important country on the Great Plains are some measure of our loss.

The photographic and pastel nature visions that follow can be said to have a cultural purpose in this

sense: in different ways, we have experienced the Texas Plains and found them magnificent and ecologically unique, and have concluded that a human future on the Southern Plains that fails to preserve for society large regions where the plains wilderness can begin to recover will not be a wise future. Given present agricultural and environmental trends on the rural Texas plains, the possibilities are there if we can only imagine them: greatly expanded national grasslands, for example; state nature preserves and county wilderness designations; Nature Conservancy tracts to protect rare and relict species, such as the Palo Duro mouse and groves of Rocky Mountain junipers; more canyonlands state parks; perhaps a Caprock Escarpment hiking/riding trail; and probably most importantly, a renewed effort to acquire and create from the Palo Duro Canyon system a national-interest plains wilderness with the return to the wild of bison, elk, and big predators. Energy has always resonated from landscapes and into human beings by way of our particular cultural filters to manifest itself in a variety of creative and symbiotic ways. Wilderness reserves are our culture's best chance to open the tap on the power emanating from the North American landscapes that we occupy.

Canyon and *visions* are words that bear considerable freight in contemporary culture. We use them with a little bit of trepidation, but with a certain conviction of choice. In this work, canyon designates a landscape focus and is used, in part, in the title of this volume to reconcile what might seem at first to be mutually exclusive: plains as harbingers of canyonlands. *Visions*, though, implies something beyond mere experience with and exposure to a phenomenon. In the sense that Emerson thought of the word, *visions* implies some discernment of the *transcendental*. Visions are, in truth, mental images produced by the imagination. But nature visions, grounded as they are in the concrete world, are a merging point for imagination and substance.

We have been challenged in attempting to liberate this landscape energy through two aesthetic filters and three media (pastels, photographic film, and words). The painter is challenged by the photographer to record scenes faithfully, whereas the photographer is daunted by the knowledge that although any decent photograph will show what a country looks like, it is altogether a different thing to capture, as a painter does, how a landscape feels. We think we know just a bit what the landscape painter Thomas Moran and the photographer William Henry Jackson must have experienced working side by side in the Yellowstone country in the early 1870s, or how the writer Fitz Hugh Ludlow must have labored to string words that could illumine Albert Bierstadt's Western oils of the Rocky Mountains in the 1860s.

So readers of this book should understand that in grouping these pastel, photographic, and word visions, we have settled on a set of categories that not only appeal to us but that are alluded to again and again by the Indians, explorers, cowboys, and artists who first embraced this country. These old-time observers may not have recognized modern artistic convention and used the formal categories of elements, form, texture, color, and light. Nevertheless, when they spoke of how the canyonlands had moved them, they were describing the very qualities that motivate modern artists to capture the essence of this landscape.

Finally, the paired visual images that follow are not necessarily spatial pairs, but represent instead (when we have been lucky) a confluence of visions.

DAN FLORES
Yellow House Canyon, Texas

ELEMENTS

But just as we commenced dozing we were startled by a tremendous thunderstorm . . . never shall I forget the early part of that awful night. The lightning appeared to be playing about in the chasm far below us, bringing out, in wild relief, its bold and craggy sides. Deafening peals of thunder seemed rising from the very bowels of the earth. . . . The yawning abyss appeared to be a workshop for the manufacture of the storm, and there we were at the very doors when the Ruler of the elements sent forth a specimen of his grandest, his sublimest work.

GEORGE W. KENDALL
Explorer, on the rim of the
Tule Narrows, 1841

The canyons and badlands of the Texas plains are creations of the grand forces, the nature gods, of the American Southwest. The deep surgery of land building has been intermittent and catastrophic: the clash of continental plates that sent mountains skyward in New Mexico, the mass deposition of silt and sand and gravel by surging Rocky Mountain snowmelt to form the sheet of the Great Plains, the scouring of high winds and great dust storms during droughts that sometimes lasted three thousand years. By contrast, canyonation is almost minor tinkering with the earth. But it has gone on along the edges of the Llano Estacado for more than a million years as rivers have eaten around and sliced ever westward into the smooth plains sheet.

The most important and obvious of the earth-shaping elements in erosional country is gravity, acting on both water and rock. Called by the distant oceans, water falling on the plains and leaking from its aquifers cuts downward and headward towards its sources, deepening draws and arroyos into canyons. As canyons widen, gravity drags boulders and soil unceasingly toward the level of the ocean bottoms, peeling canyon walls apart from one another through slides, slumps, and rock falls. Flash floods during droughts are the most effective of canyon creators, but the process is constant and incremental, as new as the last thunderstorm or the most recent freeze.

A canyon is a diverse world and one in a state of constant change; because it is not a static environment, it is not a place for climax life communities. Climate and sunlight (exposure or protection from it) are the principal life-shaping elements, and fire the great natural regenerator, to which most lifeforms of the plains canyonlands have adapted and co-evolved over hundreds of thousands of years.

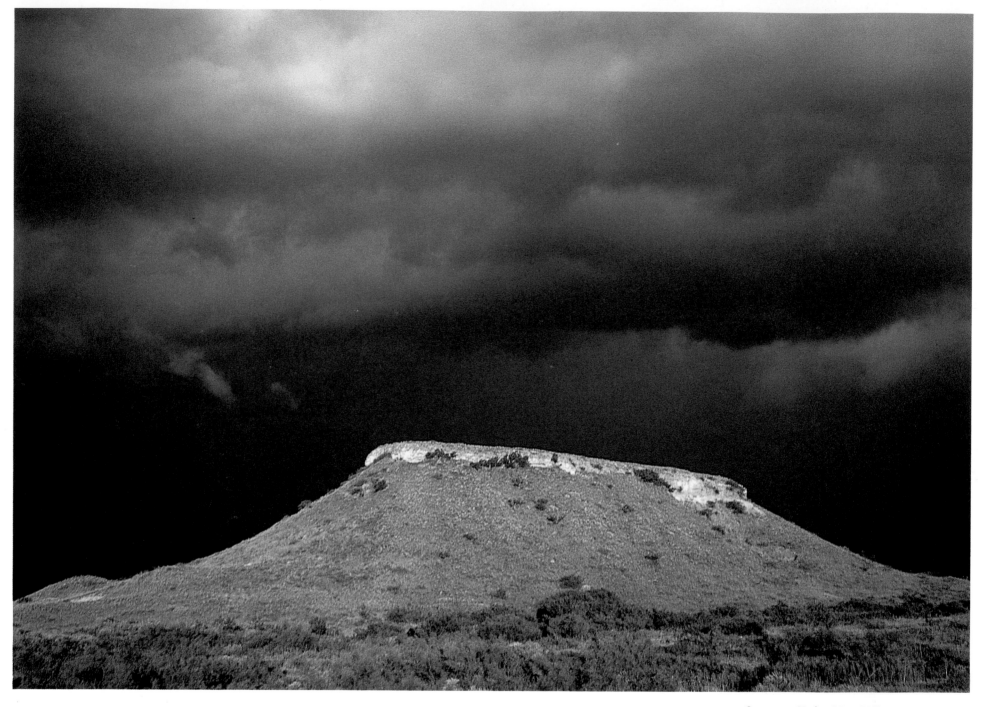

Storm over Turkey Mesa (Yellow House Canyon;
Nikon FG 35mm, Kodachrome 25).

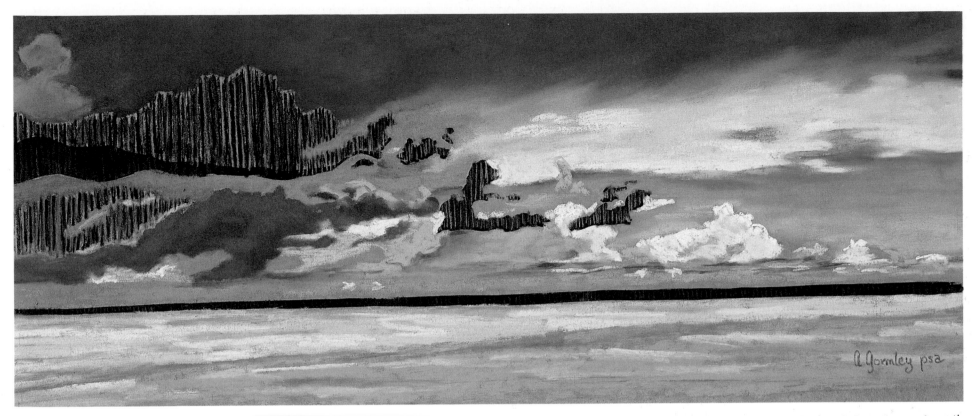

Galloping Clouds (Palo Duro Canyon; 6 × 14½ inches, collection of Tom Messer, Amarillo).

Shadowed by the Rockies to the west, whose moisture-snagging presence accounts for the semiaridity leeward, the High Plains are a battleground for weather sweeping southward from the Arctic and northward from the Mexican deserts and the Gulf. In Indian times, the violence of clashing weather systems seemed scarcely to perturb the serenity of the endless grasslands and mesas. But this was illusion.

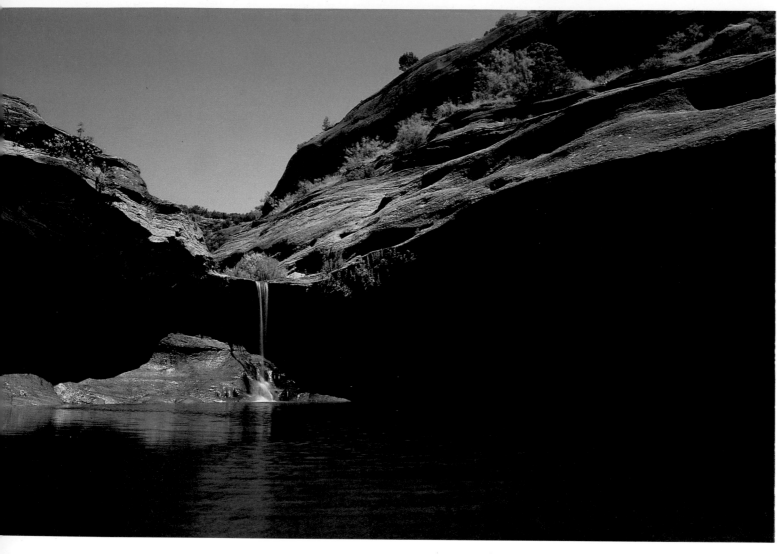

The close explosion of a plains thunderstorm in a crackle of blue-white electricity engages our senses at their limits. But it is the rain that follows that is both lifeblood and also earth-architect of erosional country. Spilling through the drainages and cascading from rock ledges, a million years of rains have sliced vertical canyons where the rocks once rested as horizontal sediments.

Lingos Falls (Los Lingos Canyon; Nikon FG 35mm, Kodachrome 25).

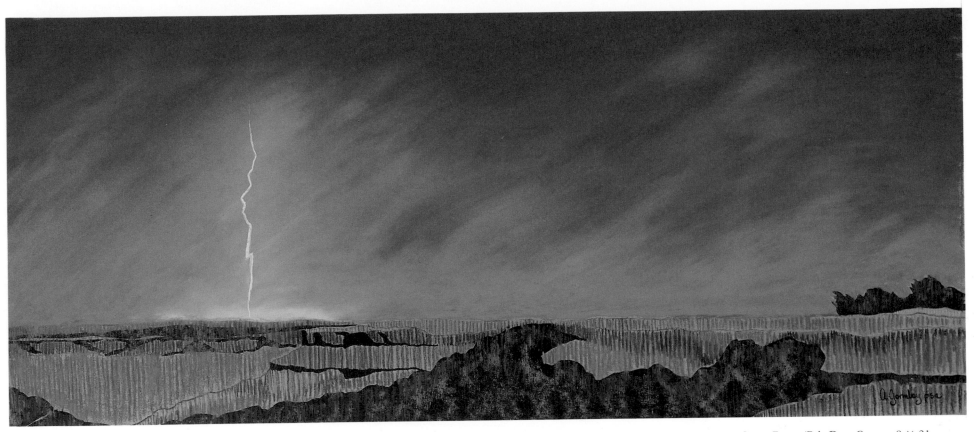

Storm Forces (Palo Duro Canyon; 9 × 21 inches, collection of Rusty Cary, Amarillo).

The thing that one cannot ignore about the inner recesses of the canyons, perhaps because it stands in such contradistinction to the plain above, is the music of water—water rippling over gravel, melting from icicles, dripping from seep springs, water nourishing ferns and cardinal flowers and 50-foot Rocky Mountain junipers. When the High Plains are parched and the playa lake bottoms are like dried tortilla shells, there is still the bubble of water in the canyons, the spigots through which the tub of the Ogallala Aquifer leaks its fossil reservoir.

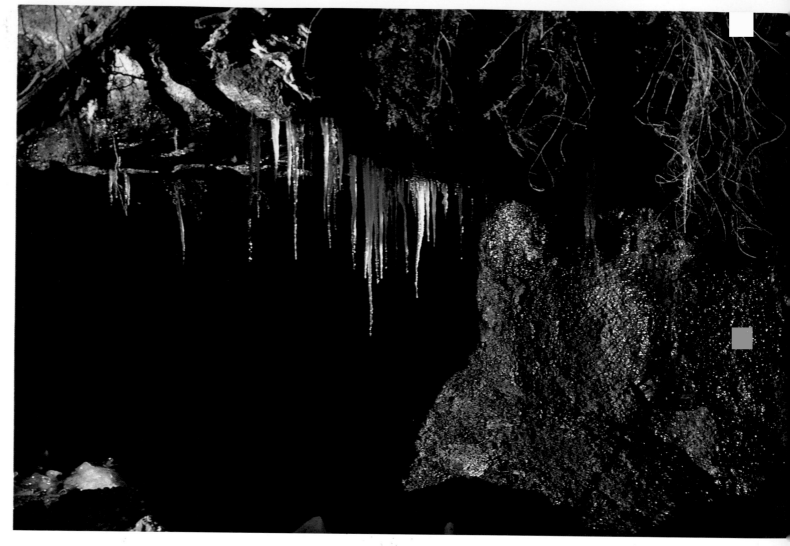

Silver Falls Icicles (Blanco Canyon; Mamiya/Sekor 35mm, Kodachrome 64).

Seep Spring in the North Prong (Caprock Canyons; 9 × 12 inches, collection of the artist).

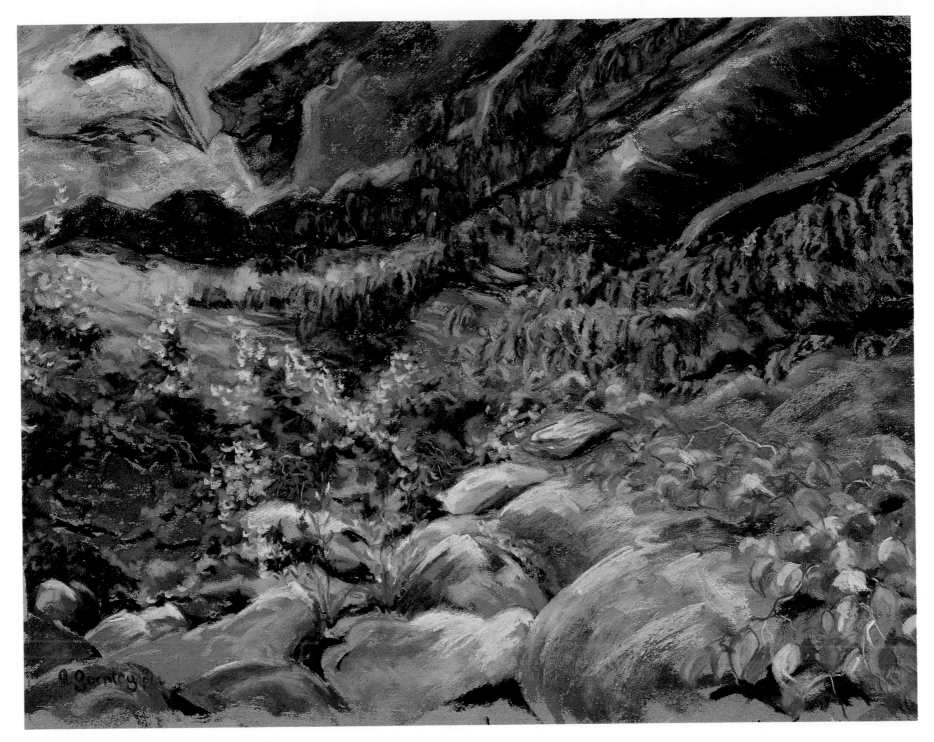

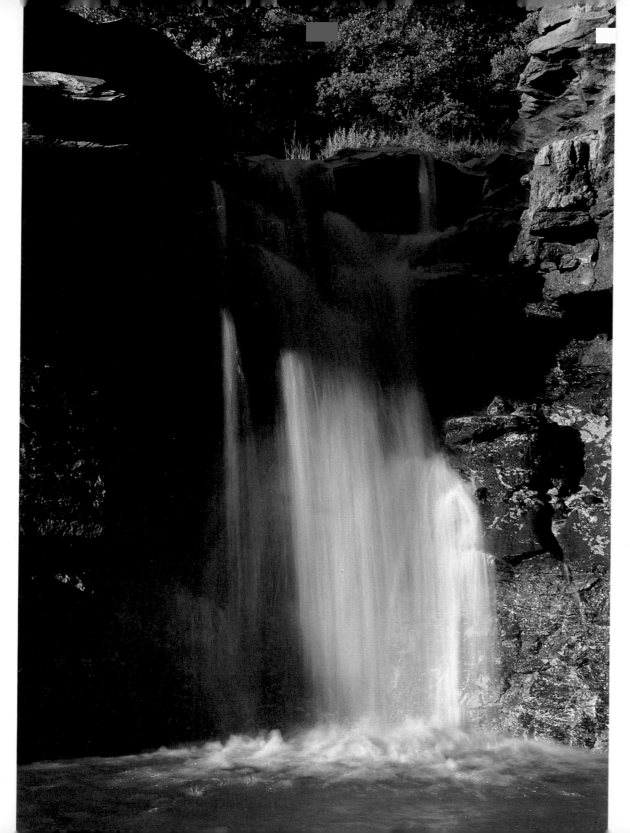

Waterfalls are unexpected delights in the steppes of the Southwest, but everywhere that the deeper side gorges and main canyon streams have cut down to Triassic rock, there are small but exquisitely beautiful waterfalls in the Llanos canyons. Indeed, at this geologic level, there is a fall line around the entire perimeter of the Llano Estacado Escarpment.

Quitaque Falls (Quitaque Canyon; Nikon FG 35mm, Kodachrome 25).

12

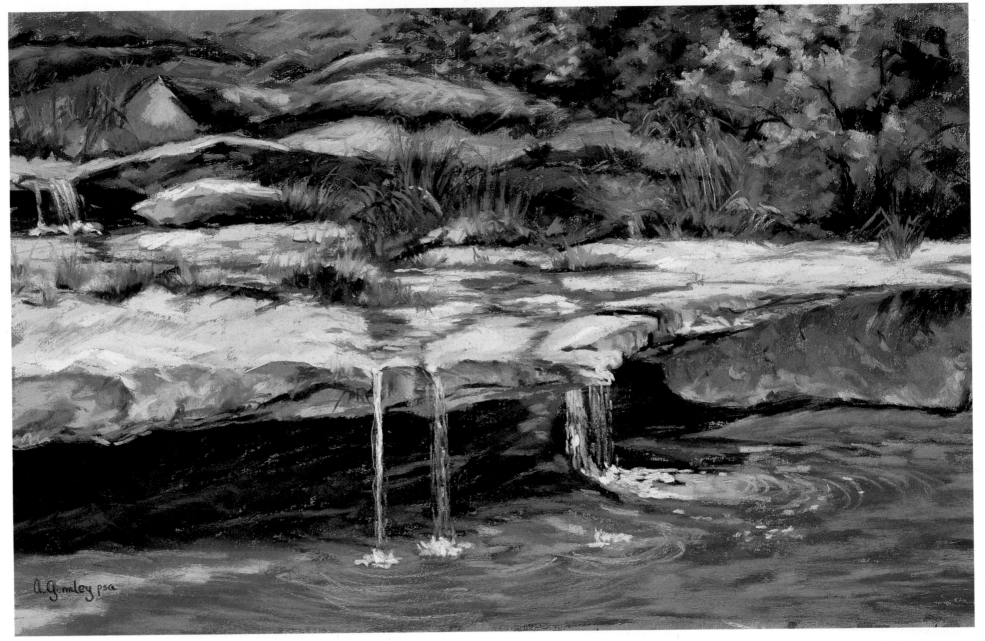

Silver Falls (Blanco Canyon; 10 × 15 inches, collection of the artist).

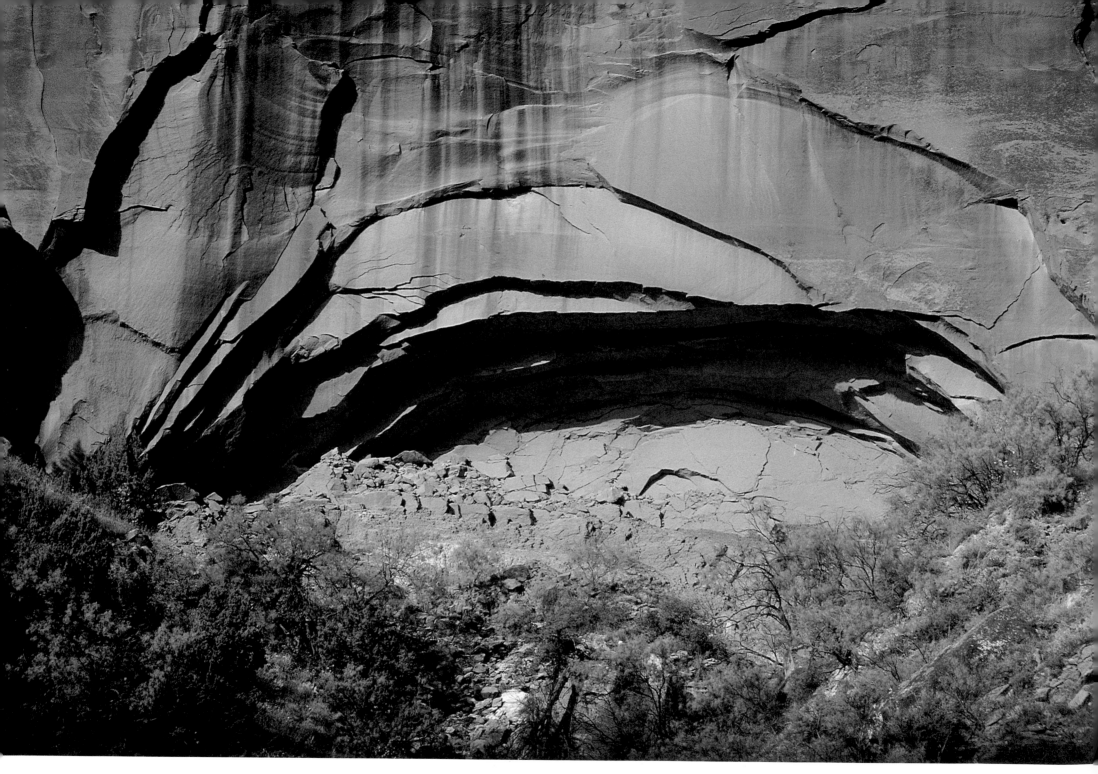

Desert varnish stripes the sheer walls of the inner gorges in mysterious and multihued patterns. What appear to be ingenious efforts at abstract painting by some secretive and airborne canyon wraith are actually the legacy of water's response to gravity, its mineral residues baked onto the rock by sunlight.

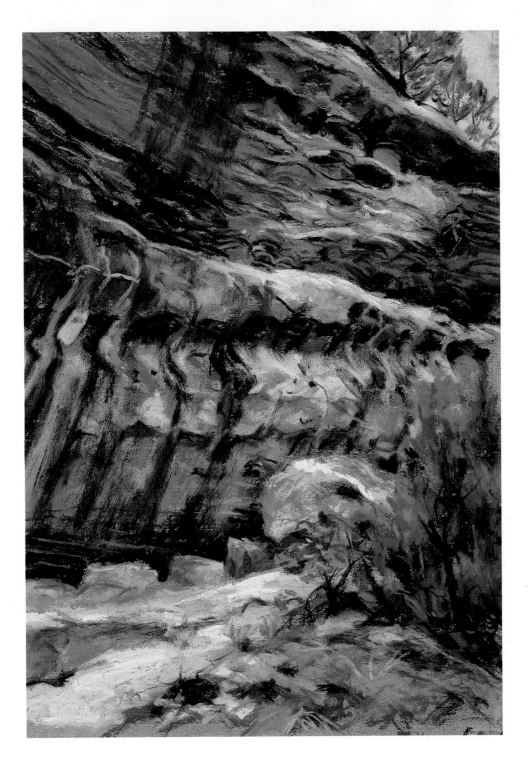

Striped Tule Overhang (Tule Canyon Narrows; Pentax 35mm, Ektachrome 64).

Desert Varnish (Caprock Canyons; $8\frac{1}{2} \times 5\frac{1}{2}$ inches, collection of the artist).

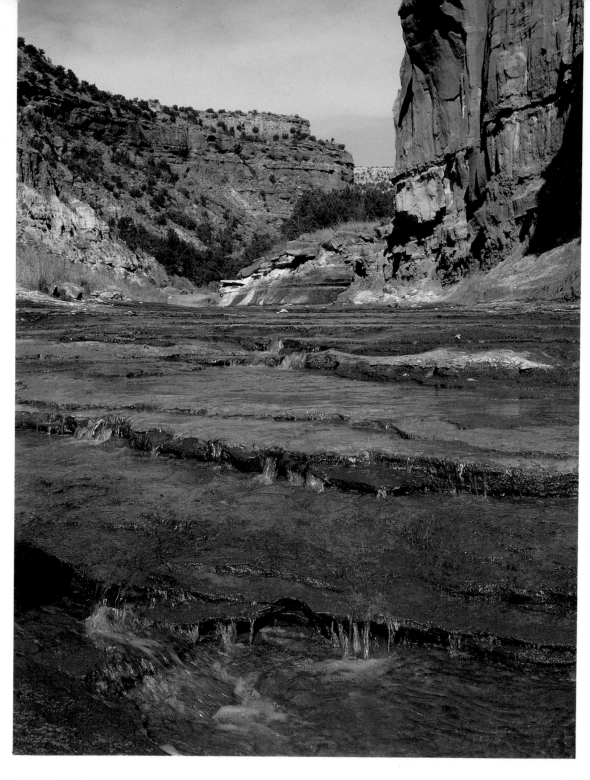

The trickling streams that course through canyons seem antipodes to the stunning, often sublime scenery that they have fashioned. Even before the Ogallala Aquifer was drawn down, when springs gushed in the side gorges, how could such tiny flows have cut 700-foot sheer walls through layers of rock? Immense time is, of course, the answer.

Tule Floor (Tule Canyon Narrows; Pentax 645, 2¼, Kodachrome 64).

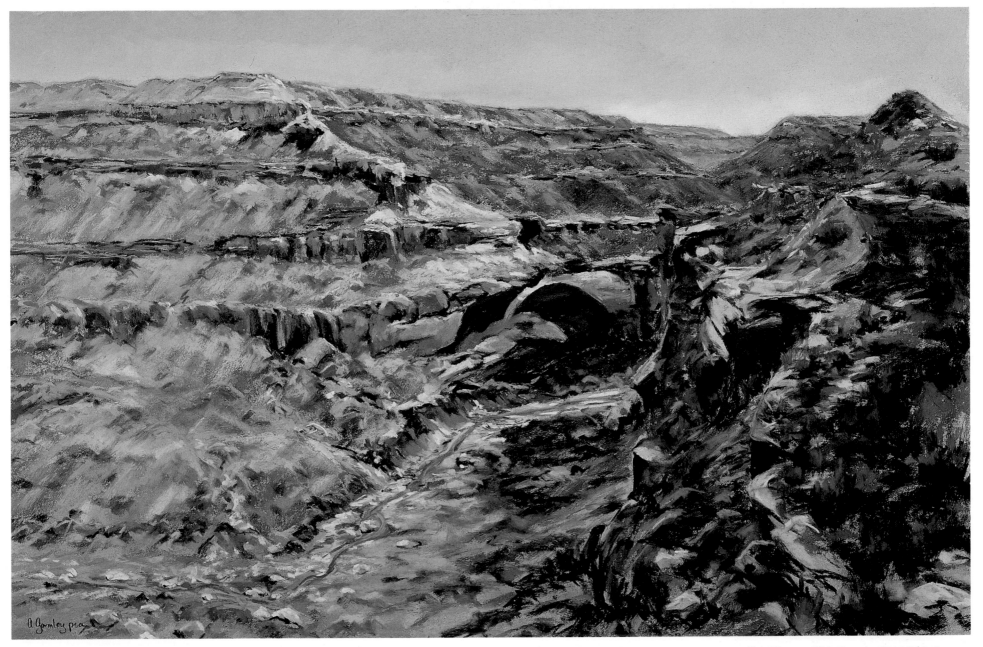

Tule Narrows (Tule Canyon; 17 × 26 inches, collection of the artist).

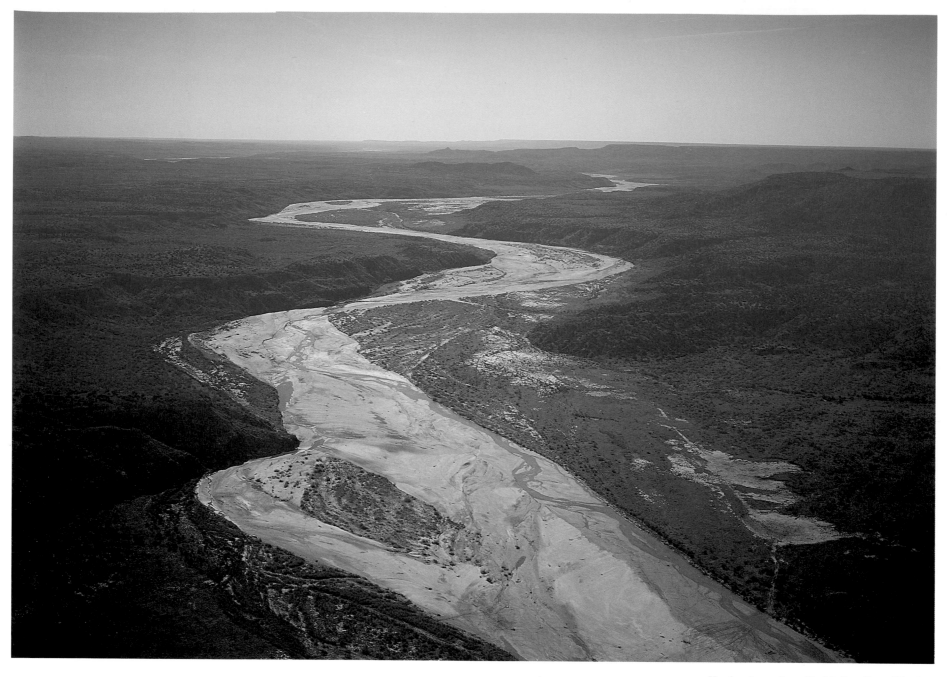

Ke-che-ah-que-hono (Prairie Dog Town River)
(Palo Duro Canyon; Pentax 645, $2\frac{1}{4}$,
Kodachrome 64).

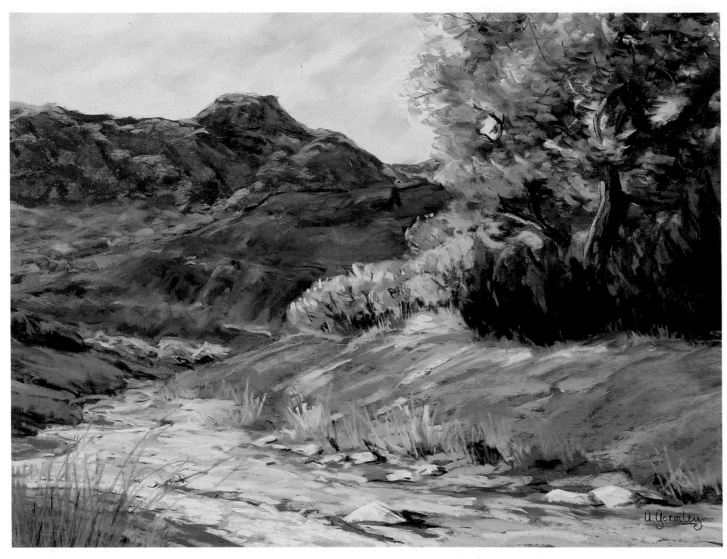

Their flows alternately sinking entirely into the sand and then reemerging downstream, the water usually clear but undrinkable after passing through gypsum near their mouths, the canyons eject coiling white ribbons of sand and salt and water eastward into the Rolling Plains.

Prairie Dog Fork (Palo Duro Canyon; 12 × 16 inches, collection of Jim and Loretta Pfluger, Canyon, Texas).

Elemental (Yellow House Canyon; Nikon 35mm, Ektachrome 200).

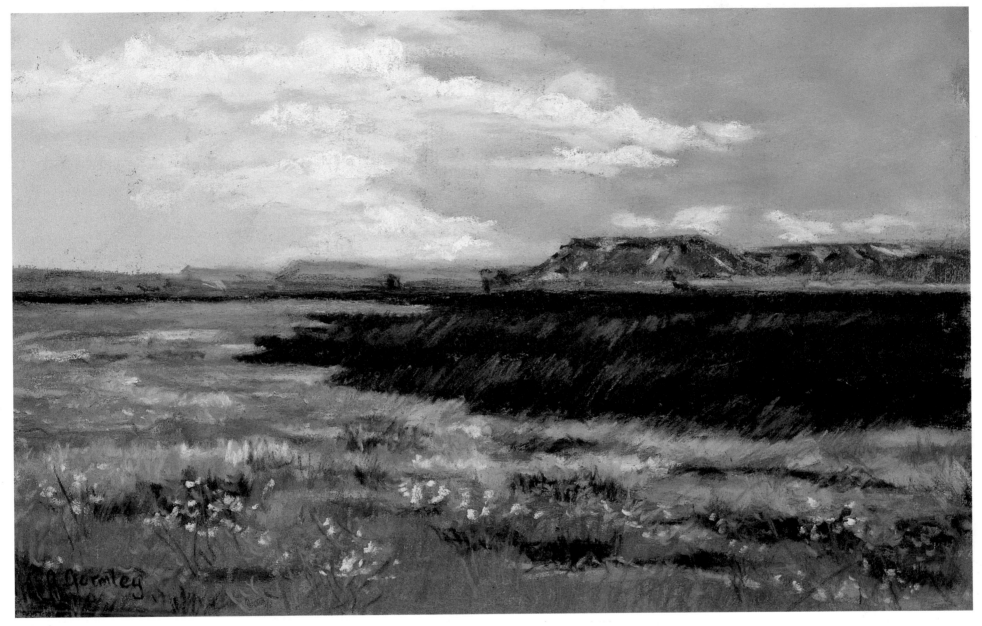

After the Fire (Yellow House Canyon; 6 × 9 inches, collection of the artist).

For 12,000 years, men and women have tended, feared, set, and fought fires on the Great Plains. Native Americans knew many millenia ago what ecologists have recently accepted as truism: what the plains once were was in important ways the work of frequent fires, and without them the plains become something ecologically different. The regeneration of a grassland canyon after fire is a lesson in wonder at rebirth in nature.

FORM

The magnificence of the views that presented themselves to our eyes as we approached the head of the river, exceeded anything I have ever beheld. It is impossible for me to describe the sensations that came over me, and the exquisite pleasure I experienced, as I gazed upon these grand and novel pictures [of] unreclaimed sublimity and wilderness.

RANDOLPH MARCY
Exploring Palo Duro
and Tule Canyons, 1852

Measured against the great canyons and gorges of the farther West, the Llano Estacado canyonlands seem drawn on a miniature scale. The deepest are no more than 1,000 feet from rimrock to floor, and Palo Duro, at 60 miles, is the longest. But even on a reduced scale and in younger rock, the plains canyons are topographically closer to the Colorado Plateau canyons than to any other American landforms. Their visual impact is quintessentially Southwest.

What makes canyonated country so interesting is its variety. On the ground, canyonland forms can seem a confused jumble; the same terrain seen from the air, from the perspective of a hawk, reveals certain forms and patterns repeating themselves again and again, as ontogeny recapitulates phylogeny in one geologic layer after another. Differential erosion between alternately hard and softer rock creates overhangs and balanced pedestals and waterfalls in predictable places. Mesas form at one geologic level; buttes and spires, at an older one. The variety of architectural forms possesses an order much as plants on a sloping wall arrange themselves according to laws of occupancy.

It should not surprise us that since ancient times, we humans have perceived the anatomy of the landscape in terms of our own anatomy, or have tried to mirror with our architecture the angular cliffs of mountains and canyons or the cathedral hush of a great forest grove. All of our primal ideas of beauty, symmetry, line, and form came from our observations of the natural both within and without ourselves.

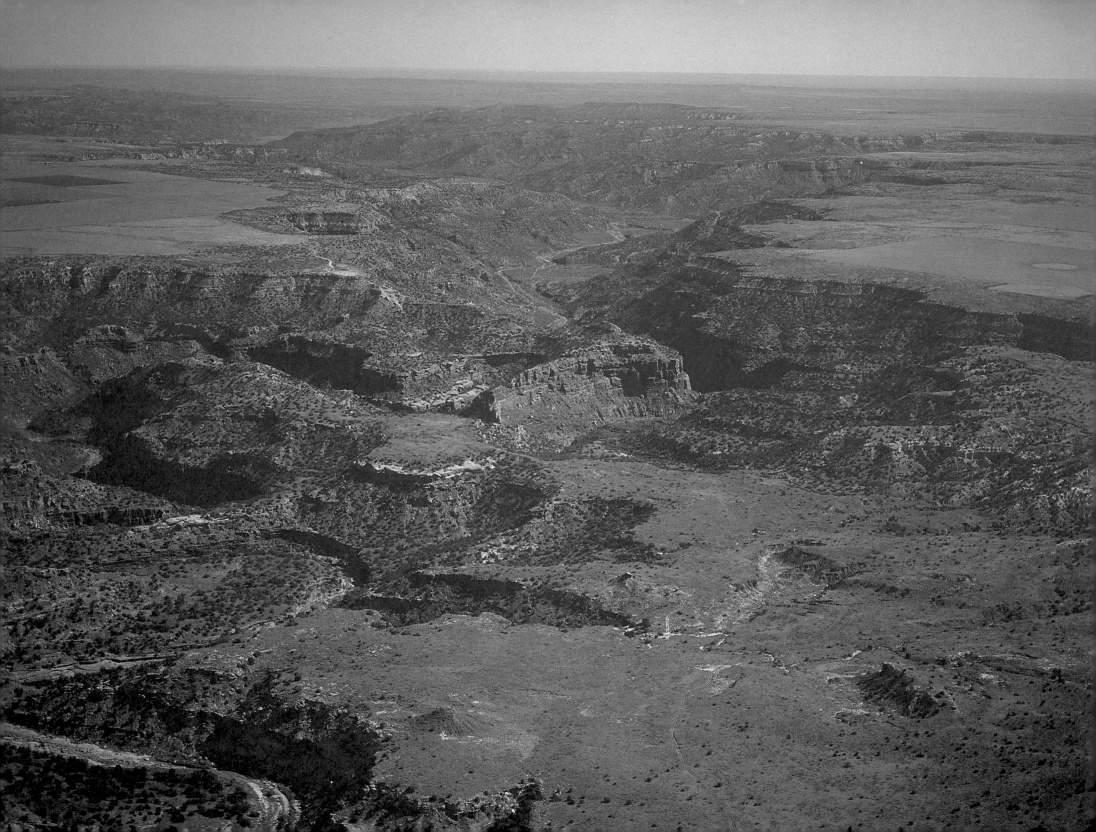

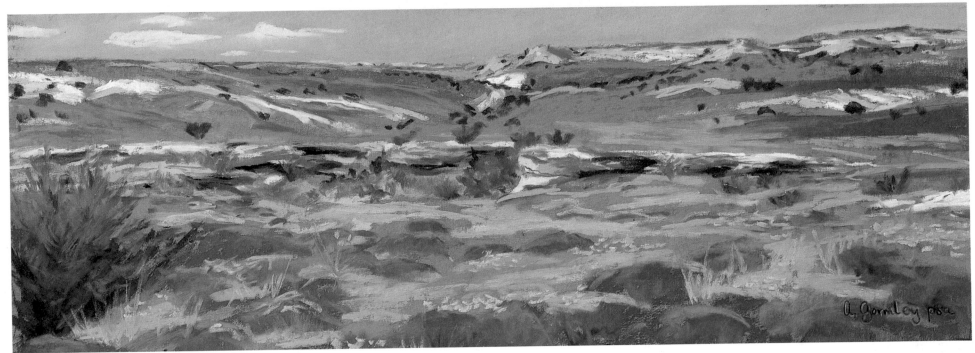

A Certain Character (Tule Canyon; 5 × 14 inches, collection of the artist).

An eagle's-eye view of a canyon such as Tule reveals, in the V-shaped erosional tangle, repeating patterns within truncated, stepping-stone tiers that lead from rimrock to canyon floor. We can profit from our occasional glimpses of the earth the way an eagle sees it; these glimpses enable us to imagine the whole writhing musculature even from the narrow slice of surface visible to earthbound eyes.

Tule Canyon, Eagle's View (Tule Canyon; Pentax 645, $2\frac{1}{4}$, Kodachrome 64).

It is the sudden interruption of the restful horizontal plane by a detached, hemispheric mound, or the descending diagonal lines of an arroyo leading the eye to unexpected intricacy, that has always made humans pause at a canyon rim and let sight outrun the other senses.

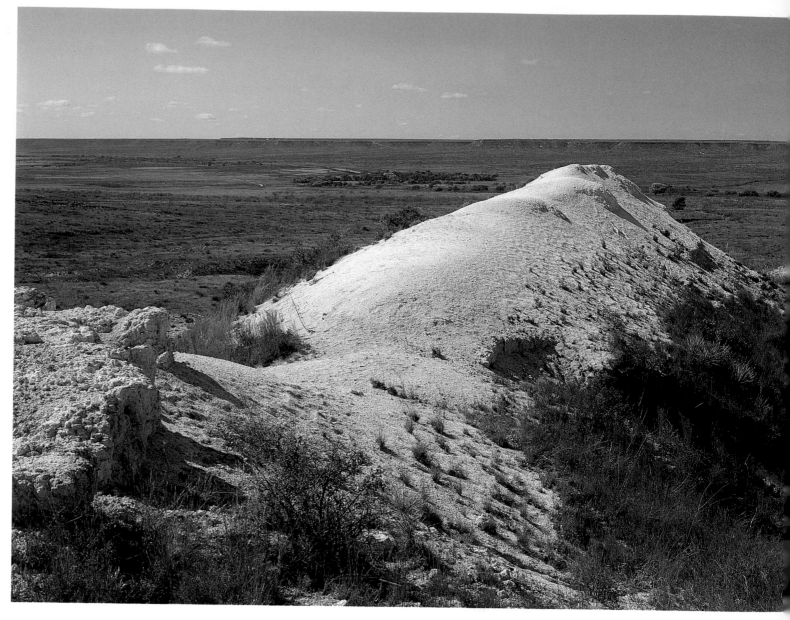

Mount Blanco (Blanco Canyon; Pentax 645, $2\frac{1}{4}$, Kodachrome 64).

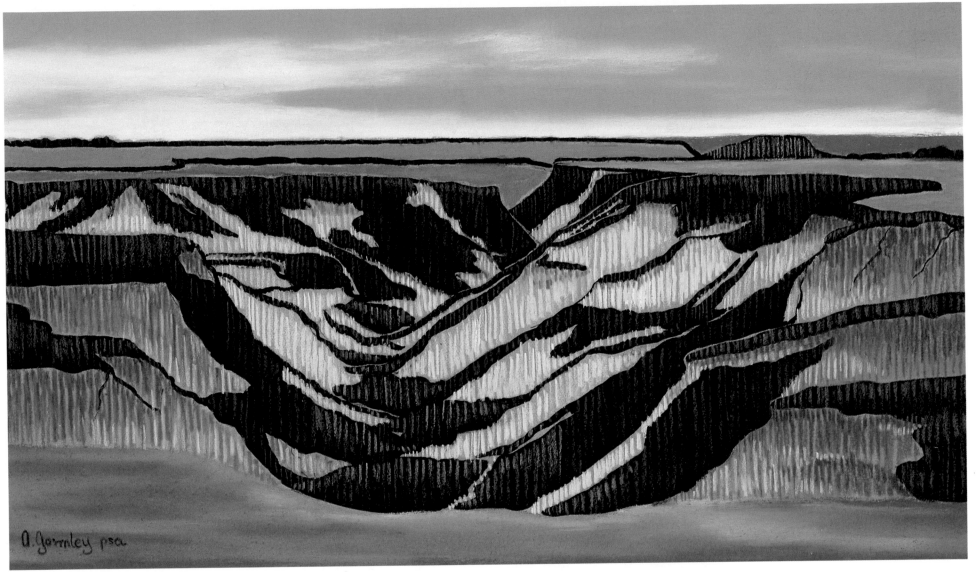

Blanco Canyonscape (Blanco Canyon; 7 × 12 inches, collection of the artist).

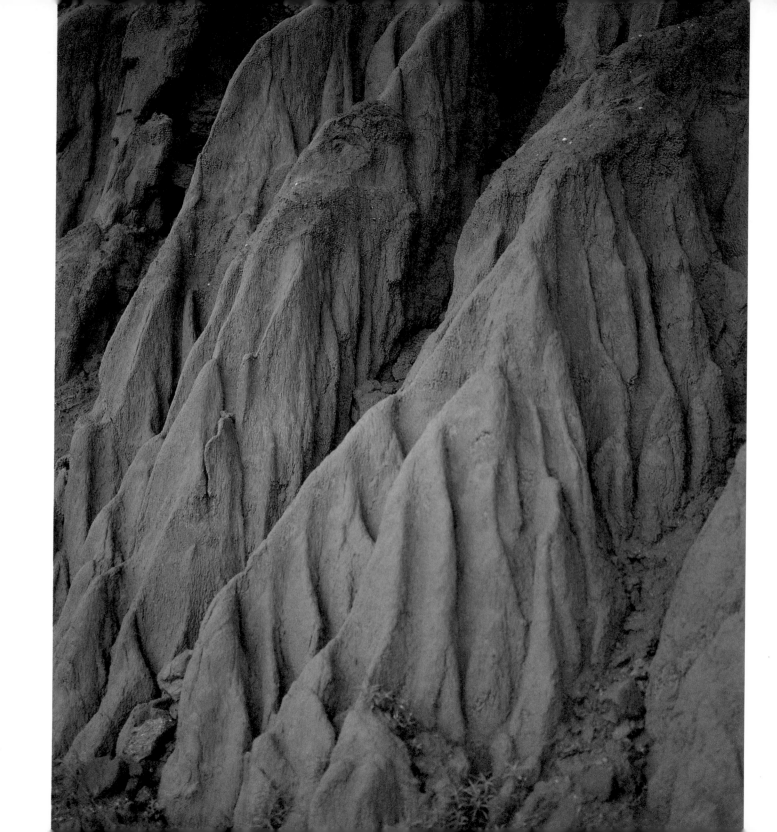

Claude Crossing Erosion Rills (Palo Duro
Canyon; Pentax 645, $2\frac{1}{4}$, Kodachrome 64).

Erosion and gravity attack weakness in clay and rock. The resulting forms are more often curvilinear than linear, for except on the ocean floor, earth energy and water energy rarely exist in perfect opposition, as in the balance of the Yin and the Yang.

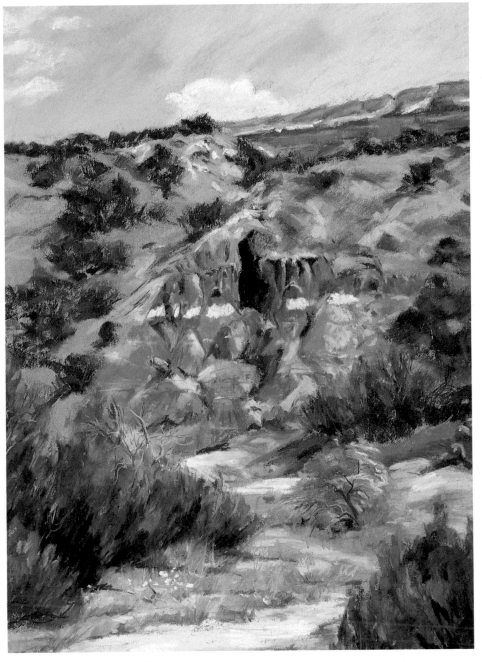

Palo Duro Cave (Palo Duro Canyon; 12 × 9 inches, collection of the artist).

The variety of forms and counterforms in canyonlands country accounts in part for our fascination with it. Red, slickrock Dockum sandstone and slipping shale caps echo one another across green and grassy meadows. In naked badlands, lichens and shadowed hollows in weirdly eroded rock reproduce a configuration that suggests the world of the barely animate.

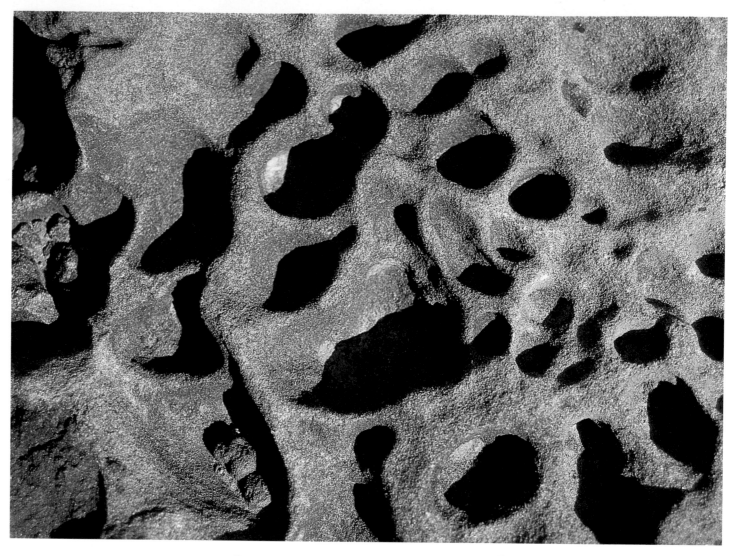

Erosion Shadows (Double Mountain Fork Canyon; Nikon 35mm, Kodachrome 25).

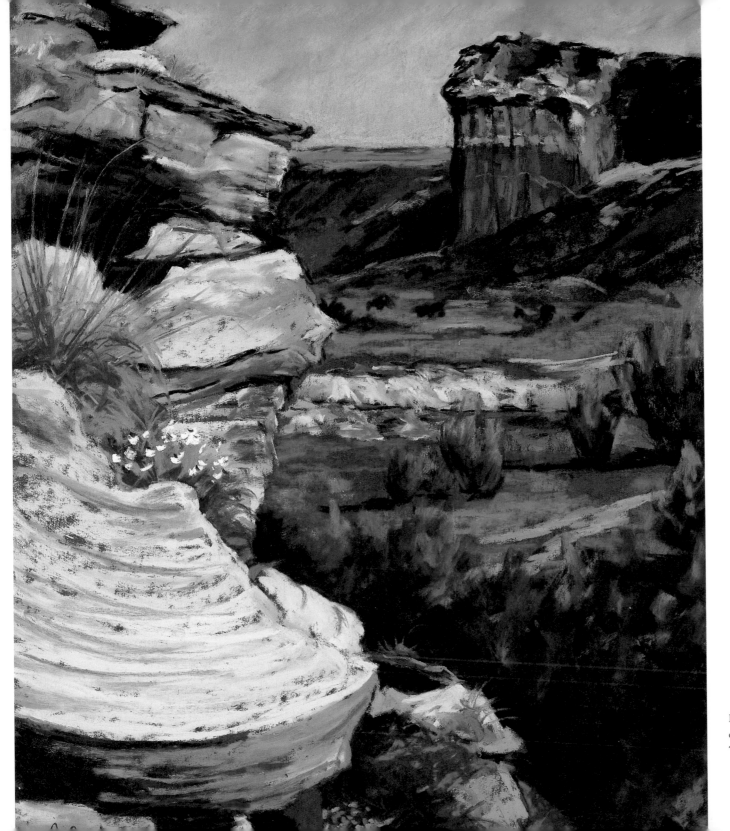

Erosion Echoes (Tule Canyon; $12\frac{1}{2} \times 9$ inches,
collection of Dan Flores, Yellow House Canyon,
Texas).

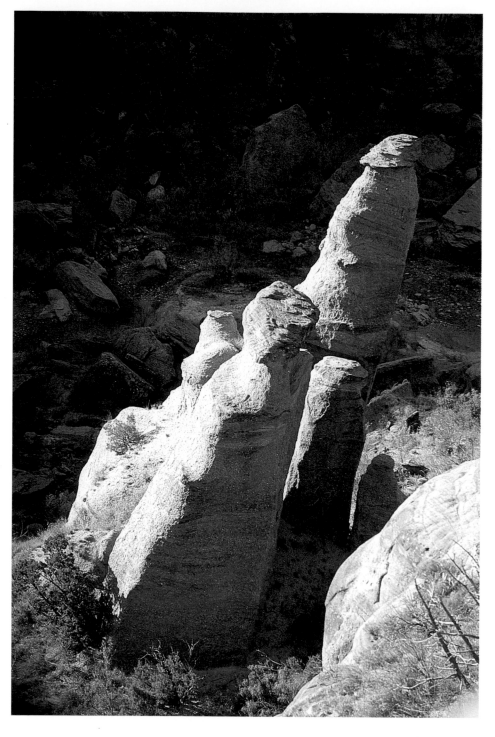

"The next march brought us to the main Cañon of Red River, and a gorgeous sight the first view of it was. Down one of its side cañons we looked on the strange scene. . . . The whole[,] so washed and twisted shapen as to marvel the eye with its intricacy and daze it with its brilliancy, formed a wild and enchanting scene."

ERNEST H. RUFFNER
Exploring the Red River
canyonlands, 1876

Family of Spires (Tule Canyon Narrows; Pentax 35mm, Kodachrome 64).

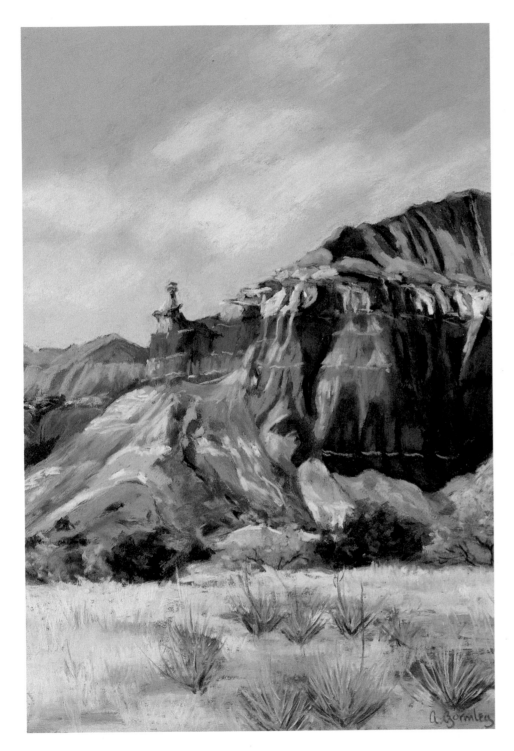

Capitol Peak Hoodoo (Palo Duro Canyon; 12 × 8 inches, collection of the artist).

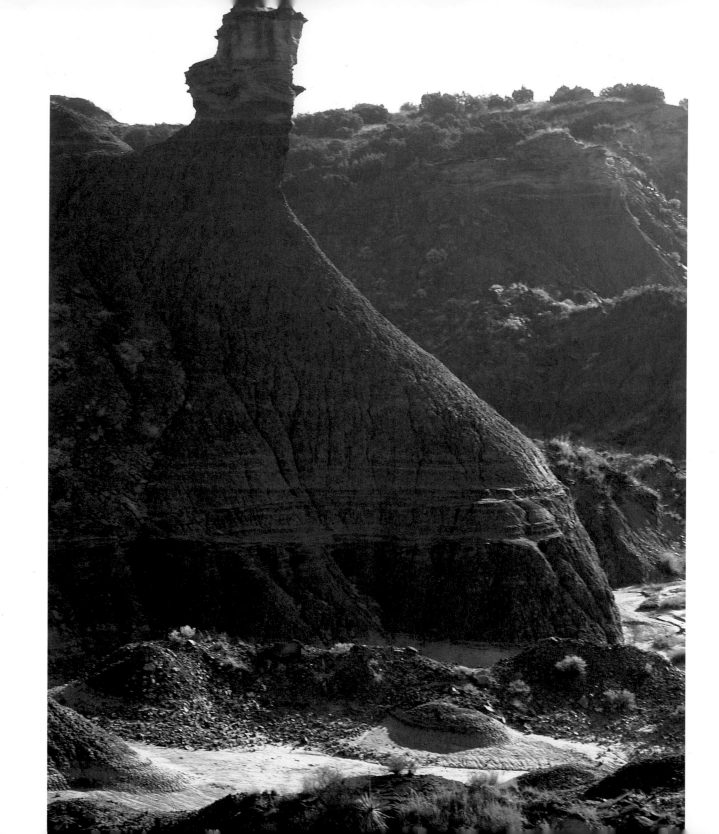

Badlands Hoodoo (Double Mountain Fork
Canyon; Nikon 35mm, Kodachrome 25).

The hoodoo is the geologic signature of the plains canyonlands. The supporting Permian and Triassic clays are so friable under runoff that hoodoos exist in geologic time for only a fraction of an instant, literally a balancing act of rock atop a melting clay column. Eroded badlands mounds tell of hoodoos lost and gone but others are forming constantly.

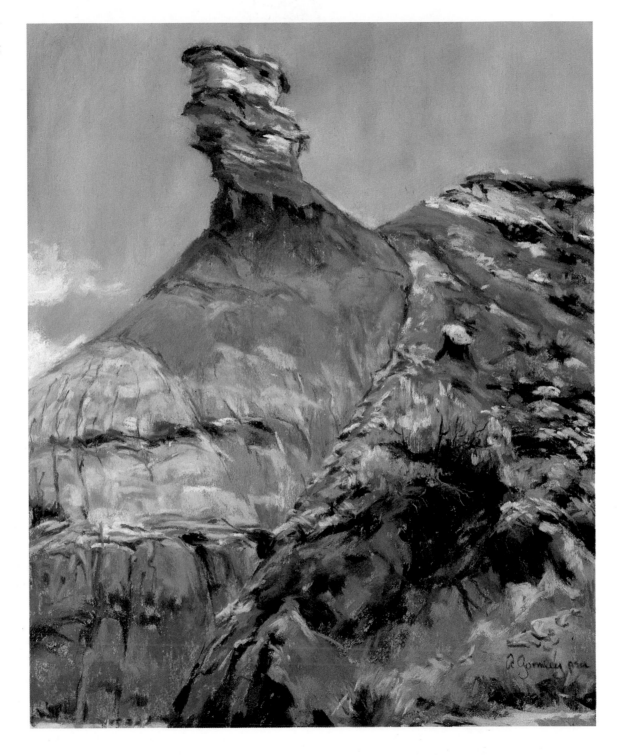

Lost Hoodoo (Double Mountain Fork Canyon; 13 × 10 inches, collection of the artist).

Some erosional canyonlands forms suggest masculine energy. But despite the broken ruggedness of the terrain, for most people the gender gestalt of a canyon is female. The pan-cultural metaphor for an ascent up a canyon gorge, so widespread it must be an epiphany, is of a womblike entry into the Earth Mother.

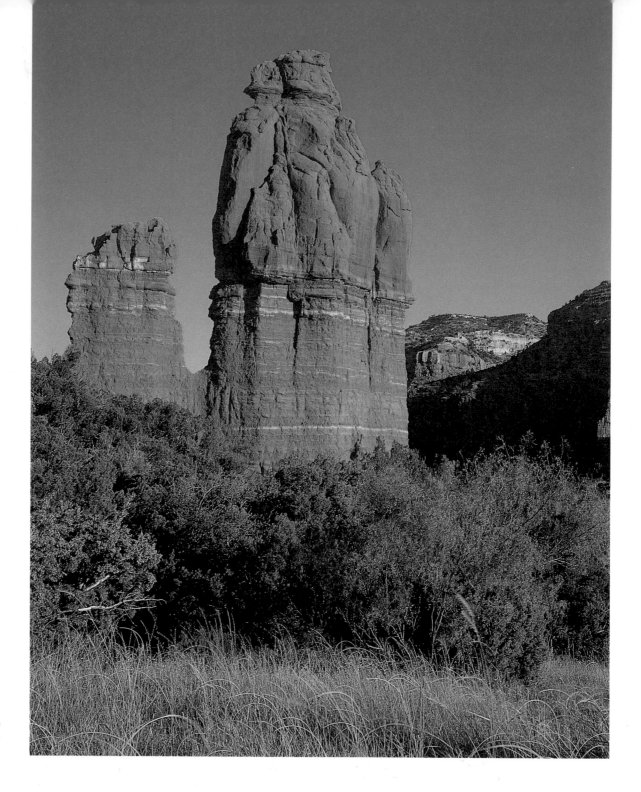

Caprock Canyons Mitten (South Prong Canyon, Caprock Canyons; Pentax 645, $2\frac{1}{4}$, Ektachrome 64).

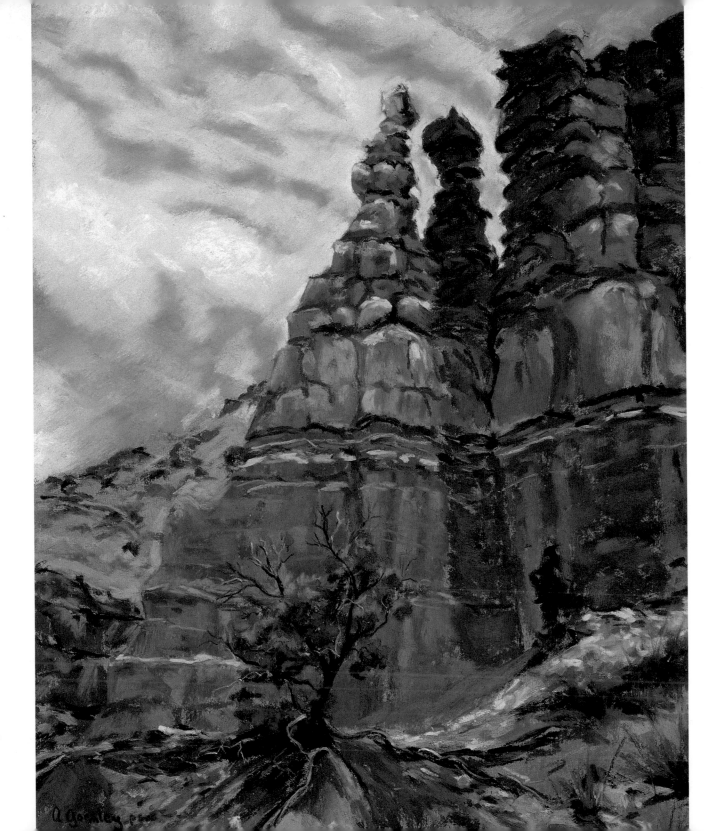

Twins on the Trail (Caprock Canyons; 12 × 9
inches, collection of the artist).

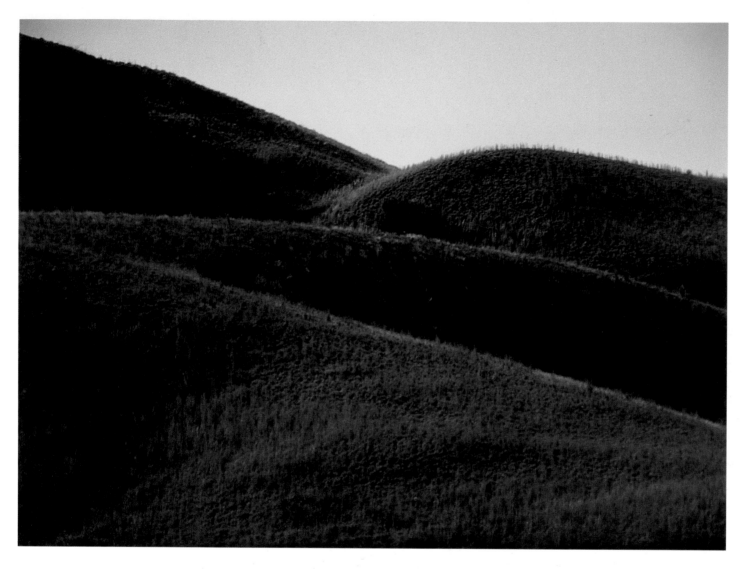

Great prairie canyons such as Blanco and Yellow House are marvels of symmetry and the rhythm of parallel forms, as rimrocks and slopes mirror each other across grassy valleys. Their upswept mesas and undulating terrain give them the organic grace of the best adobe architecture and combine with long sweeps of curving grasslands to imply a smooth femininity.

Blanco Mounds (Blanco Canyon; Mamiya/Sekor 35mm, Kodachrome 64).

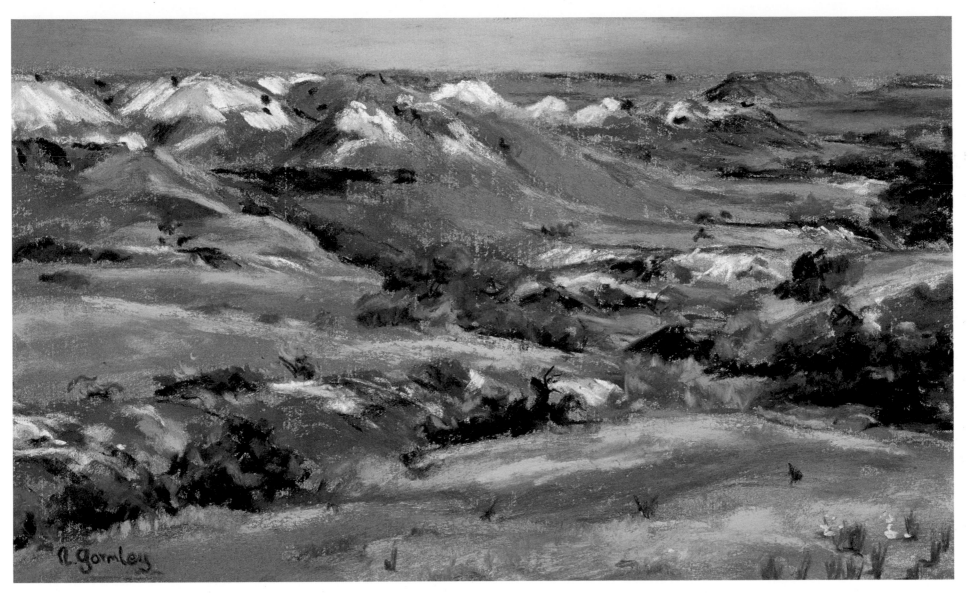

Yellow House Canyon (Yellow House Canyon;
6 × 9 inches, collection of the artist).

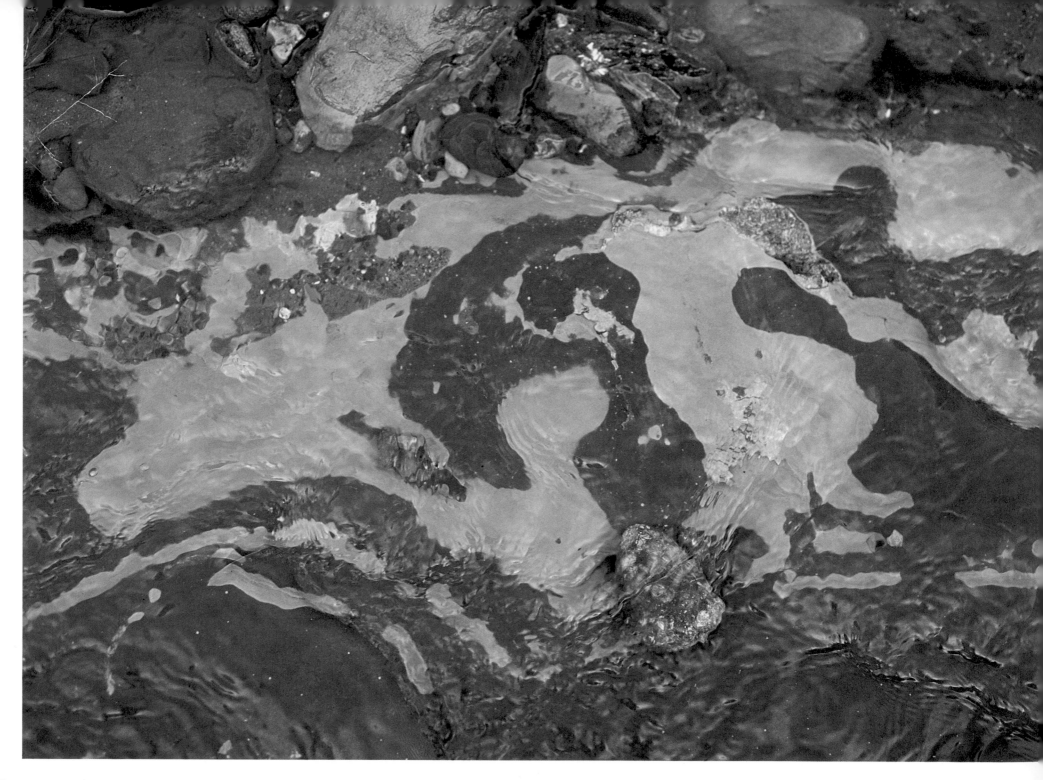

Exposed by water or the shearing of a
rock wall, swirls and veins of green
clay extend deep into the red Permian
mass that forms the basement of the
plains. Called reduction halos by the
geologists, they enable us to infer
continuum, to project three-
dimensional canyon forms into the
earth mass itself.

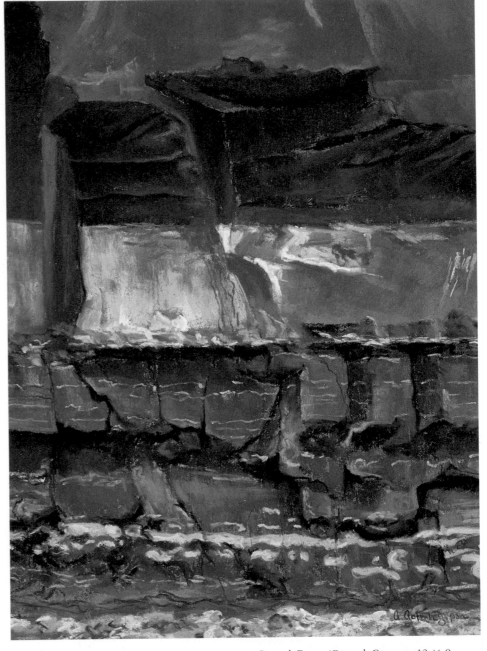

Caprock Forms (Caprock Canyons; 12 × 9
inches, collection of Ray Strickland, Amarillo).

Reduction Halos (Tule Canyon Narrows; Pentax
645, 2¼, Kodachrome 64).

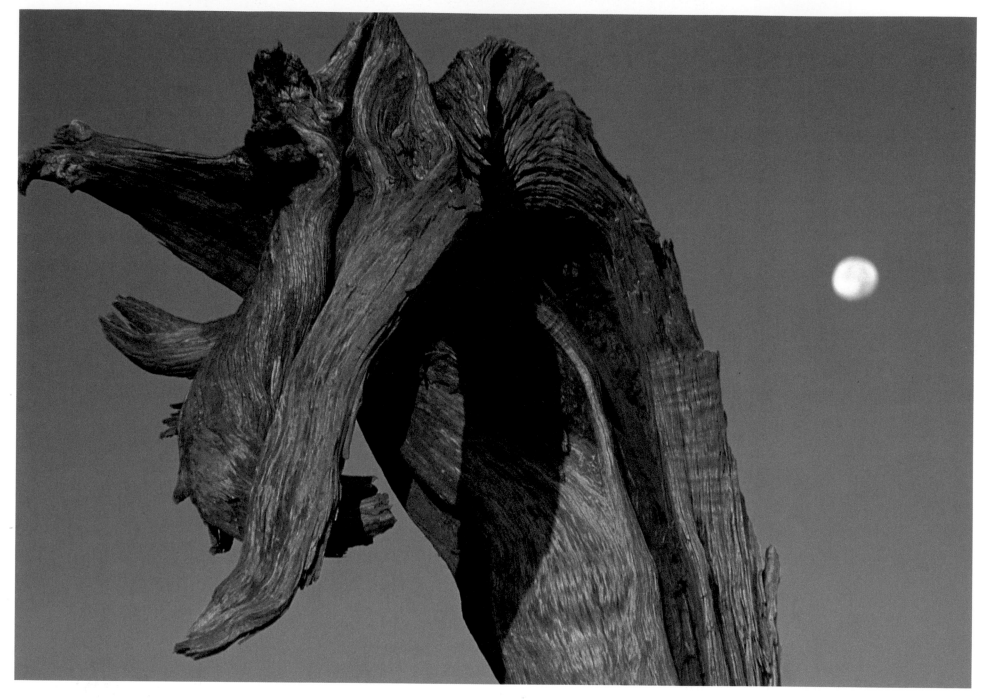

Juniper and Moon and Sky (Yellow House
Canyon; Pentax 35mm, Ektachrome 100).

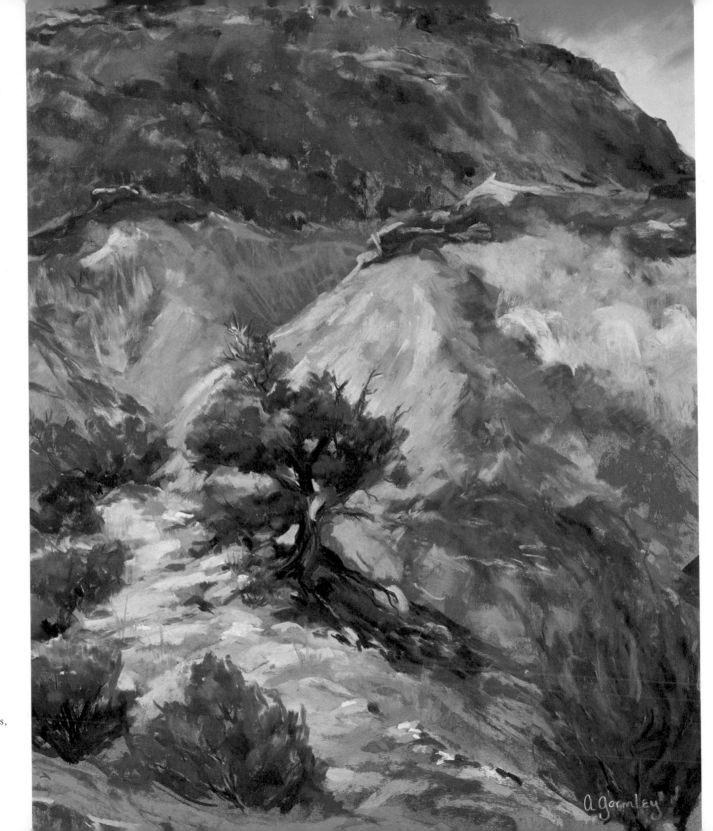

Canyonland junipers twist and coil as if, in responding to the rhythms of the decades and centuries, the animating force within them has wrapped itself into a tightening spiral. The juniper's life spiral is most evident, paradoxically, in its death. But it is present also in the springy resilience of the living tree hanging on the edge of a rimrock.

Cliffhanger (Palo Duro Canyon; 12 × 16 inches, collection of the High Plains Dermatology Center, Amarillo).

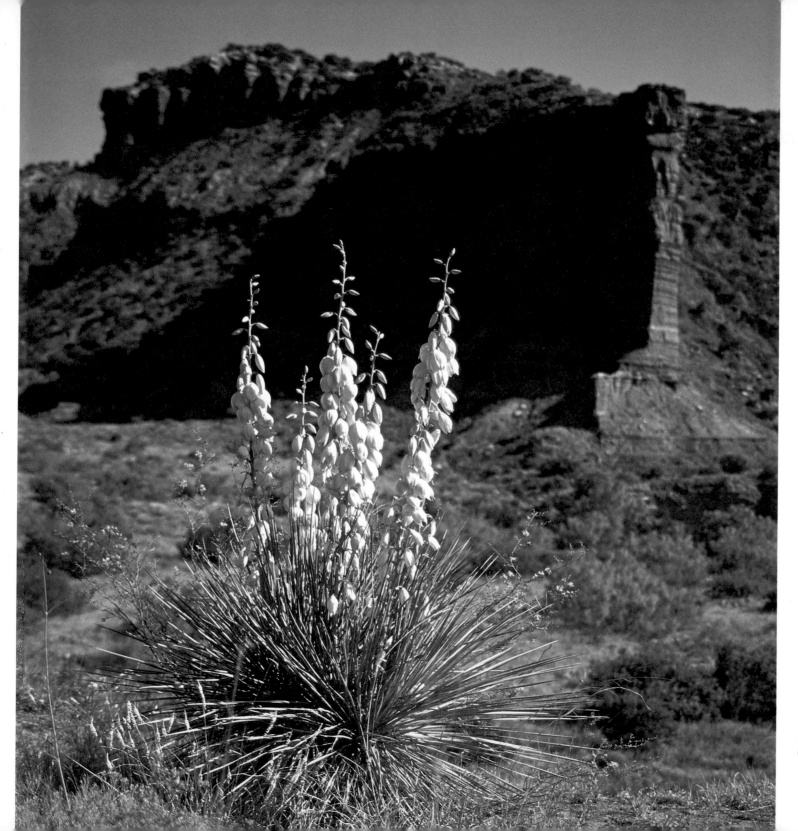

The opposition of rounded yucca
blooms with points, angles, and edges
is a striking and stark juxtaposition.
All of these forms exist in nature; the
pity is that much urban architecture has
seized on the latter to the virtual
exclusion of the former.

Blooming Yucca (South Prong Canyon, Caprock
Canyons; Nikon 35mm, Kodachrome 25).

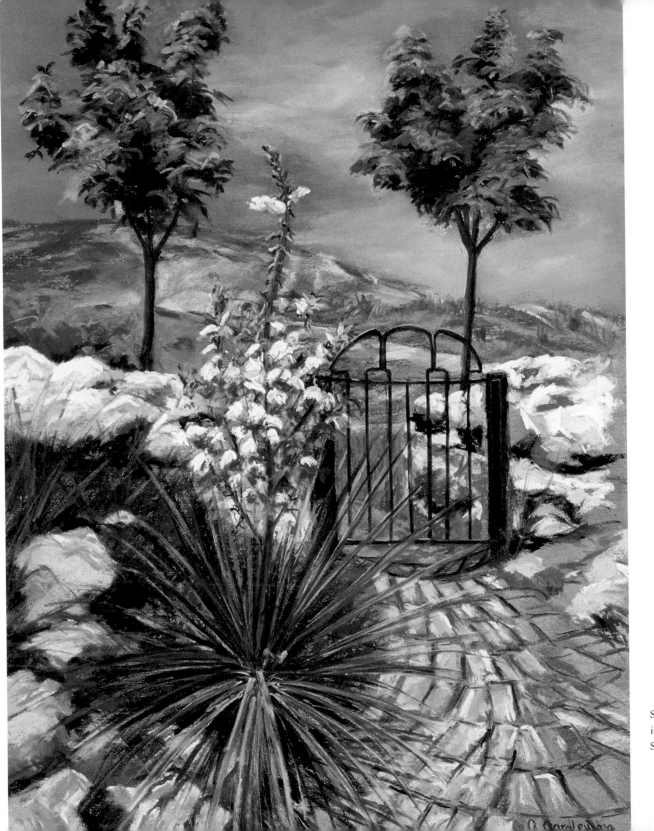

Spanish Bayonet (Palo Duro Canyon; 17 × 12 inches, collection of B. R. Smith and R. P. Smith, Jr., Amarillo).

TEXTURE

The basic purpose of every artist is to translate
sensations and ideas into an understandable image.
Walking through and looking hard at canyonlands
country, one becomes gradually conscious of a myriad of
textures intrinsic to desert canyon and plains badland
forms. Arrangements such as rocks abutting water,
sky adjoining earth, grass and caliche in tandem, and
lichens clinging to stone offer a multitude of surfaces
waiting to be recorded.

Capturing various textures on light-sensitive
photographic film can be done by creating illusion and
by enhancing relative value. In the case of illusion, a
narrow depth of field can sharpen a rough texture
and slur a background to smooth softness to heighten
a viewer's perception of surface. Before opening the
shutter, the photographer can wait for the precise
moment when dark and light values form a
configuration of textures to match his vision of the
locale. The rather extraordinary diversity of surfaces and

living forms on the Texas plains provides the landscapist
almost unlimited opportunities to investigate a wide
range of techniques for capturing texture.

A pastel painter represents texture through illusion
and relative value as well as through the actual surface
texture of the paper. On paper prepared with pumice,
the textures of a landscape can become a part of the
creative process even before the paint is applied. The
rougher the painting surface, the more pigment can be
applied, layer by layer, to build up texture. The artist
layers pigment on the surface from general impression
through fine detail work, letting the rough paper show
through if it contributes to capturing the sensory
perception of texture in the scene.

A landscapist's successful handling of texture can
accomplish a three-dimensional miracle on flat paper:
the physical presence of smooth sandstone, gnarled
wood, and rippling water.

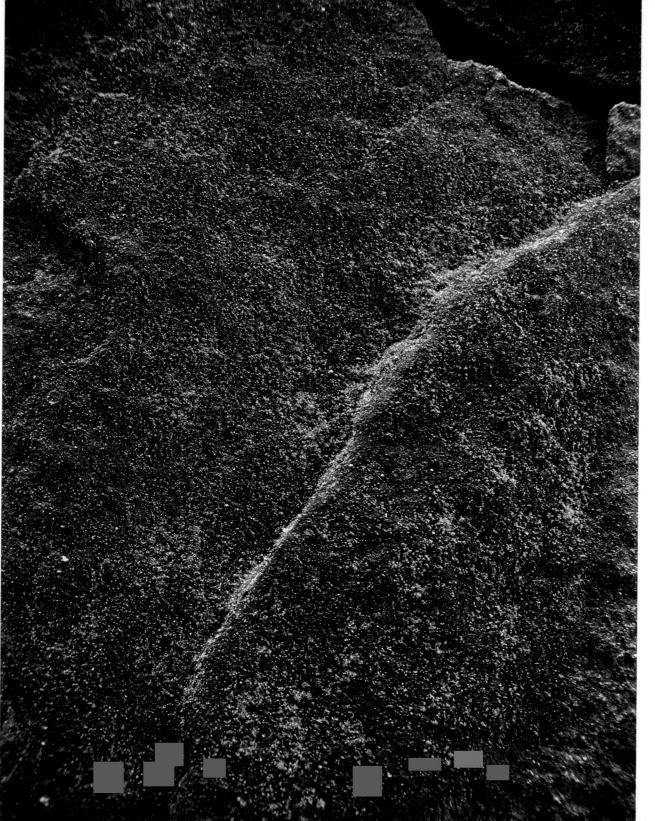

It pays to walk slowly along river beds with one's head down in a sort of pensive reverence. The reward is the surprise of finding such soft-textured microorganisms among hard, rough rocks.

Shiprock Lichens (Tule Canyon; Nikon 35mm, Kodachrome 25).

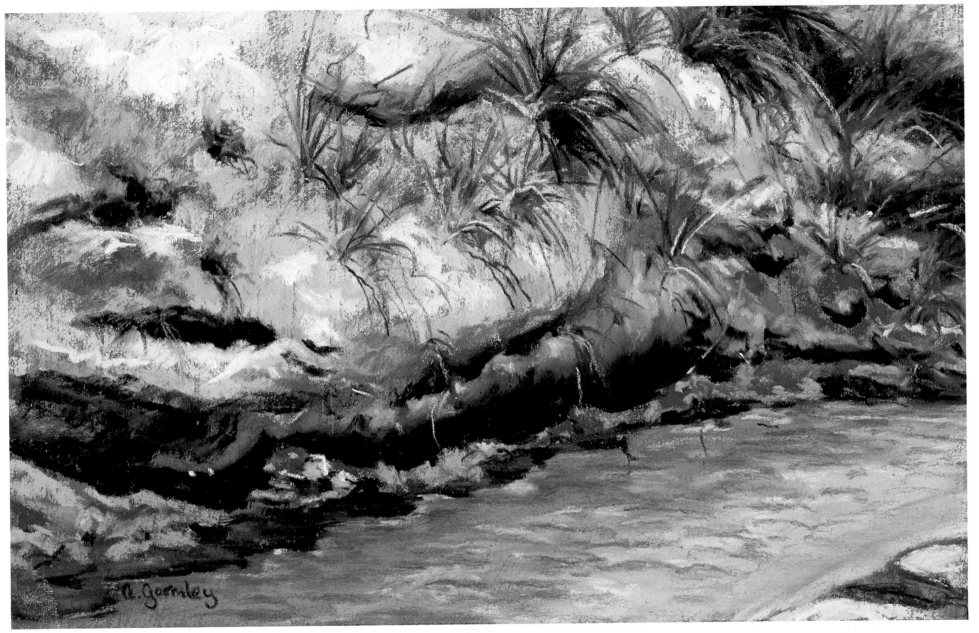

Mulberry Moss (Mulberry Canyon; 6 × 9 inches, collection of the artist).

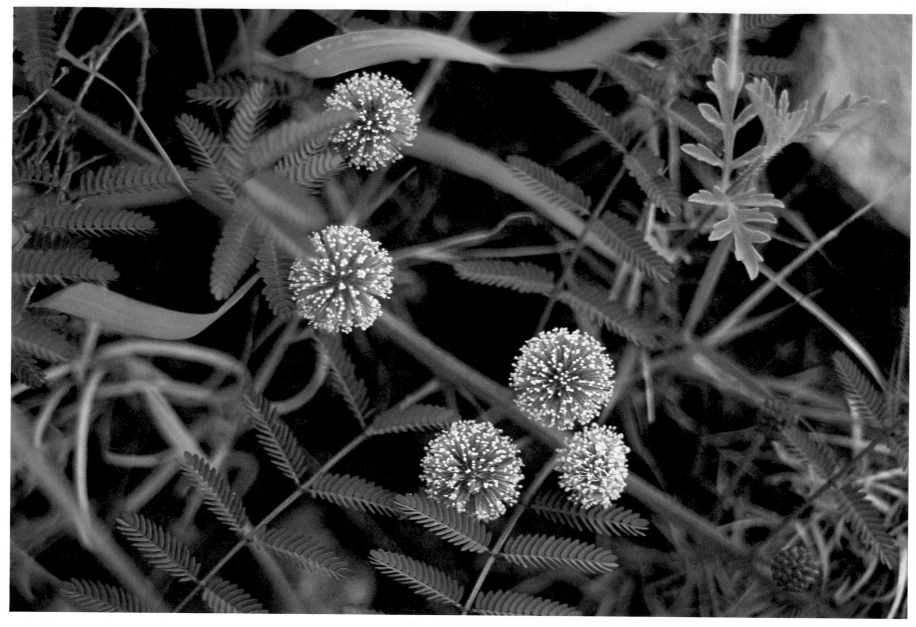

Sensitive Briar Blooms (Yellow House Canyon;
Nikon 35mm, Kodachrome 25).

Nature can dress some harsh areas of the wild with incredibly soft and delicate flowers. For a short time every spring, very ordinary salt cedars bloom soft and pink like feather boas and move in the breeze like a chorus line. Similarly, the pink flowers of the sensitive briar entice one to touch their delicacy, then shrink from the touch as if to withdraw the invitation.

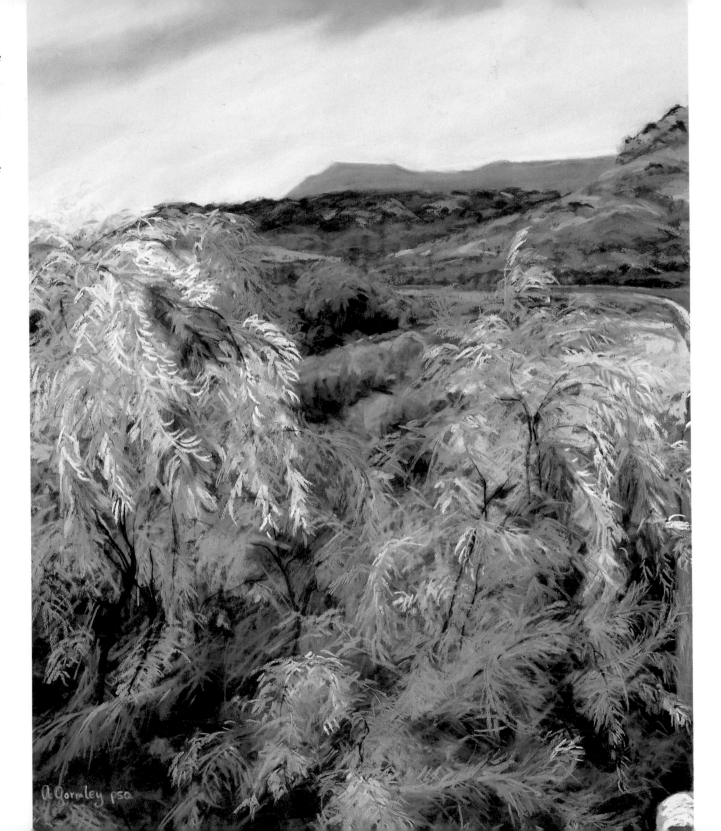

Salt Cedars at the Claude Crossing (Palo Duro Canyon; 18 × 14 inches, collection of the artist).

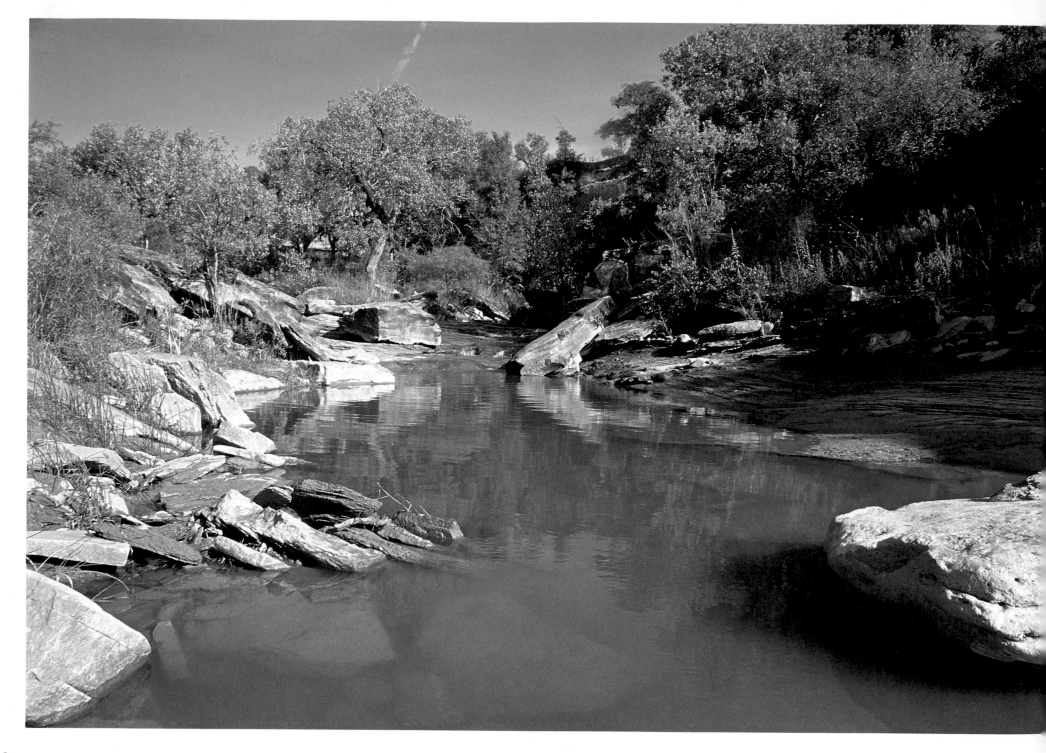

The pleasure of water in West Texas wilderness country is intensified by the tactile discovery of the contrast of its sleek coolness to the hot, sunbaked rocks, the very textural antipode of water. Bridging the opposites, we seem to join the process of the one texture shaping and smoothing the other.

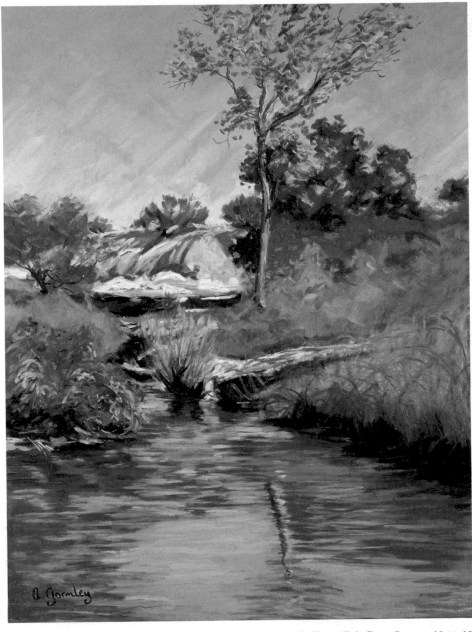

Below the Spillway (Palo Duro Canyon; 10 × 13 inches, collection of the artist).

Pools in the Tosah-Honovit (Blanco Canyon; Pentax 35mm, Kodachrome 64).

Cacti define the semiaridity of this land. They are the floral signposts of the West Texas terrain, sturdy, standoffish survivors of drought and heat—and surprising with color when the rains come.

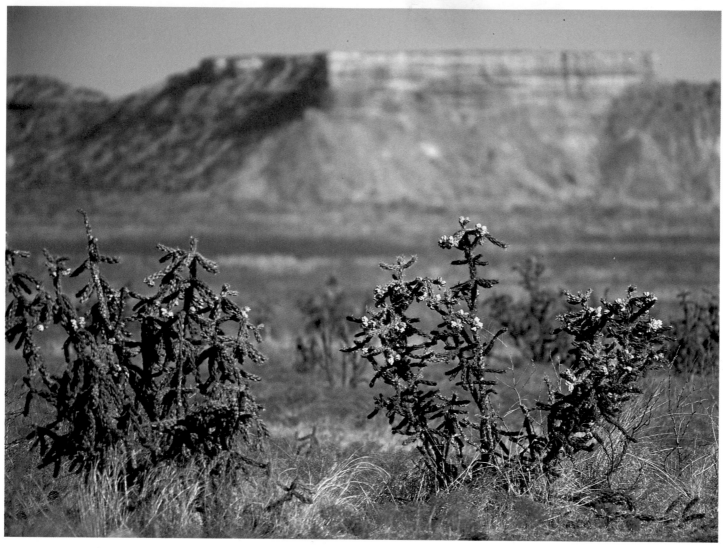

Dance of the Chollas (Double Mountain Fork Canyon; Mamiya/Sekor 35mm, Kodachrome 64).

Plains Prickly Pear (Palo Duro Canyon; 15 × 20 inches, collection of Christa Loschnigg, Graz, Austria).

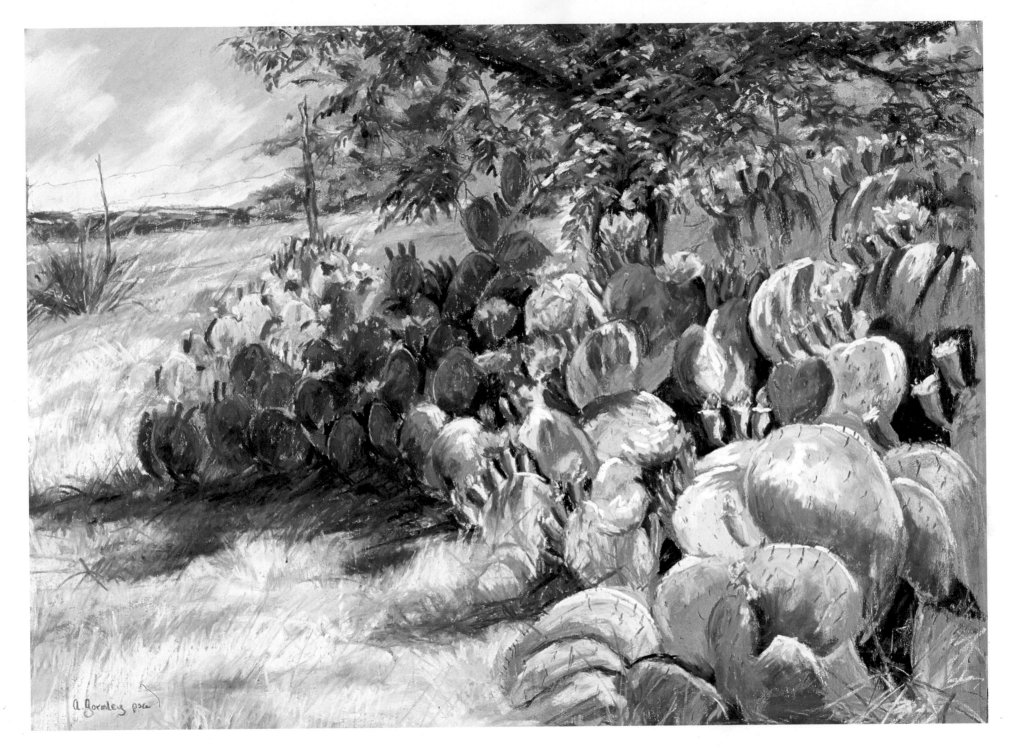

A. Gormley psa

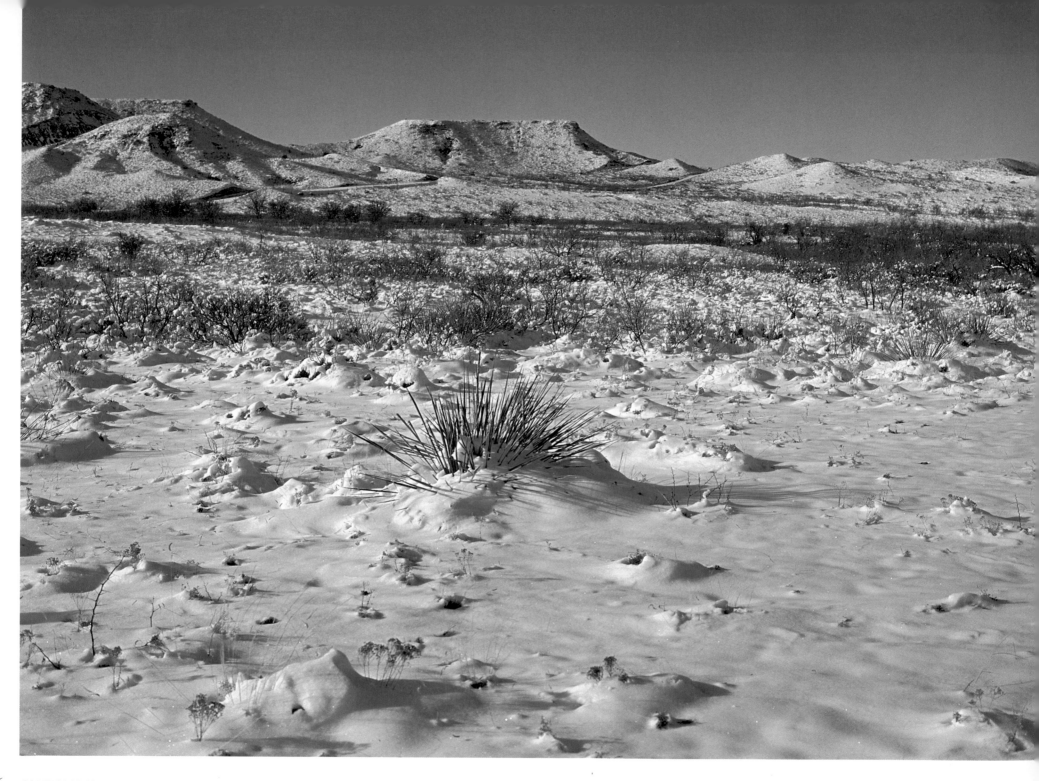

In the winter, Father Sky enfolds
Mother Earth, touching her with
substance. The frozen flakes fall
earthward out of the gray and the dark
to drape a thick, warm, white blanket
over her form, covering her gently
while she sleeps, the seed of spring in
her brown belly.

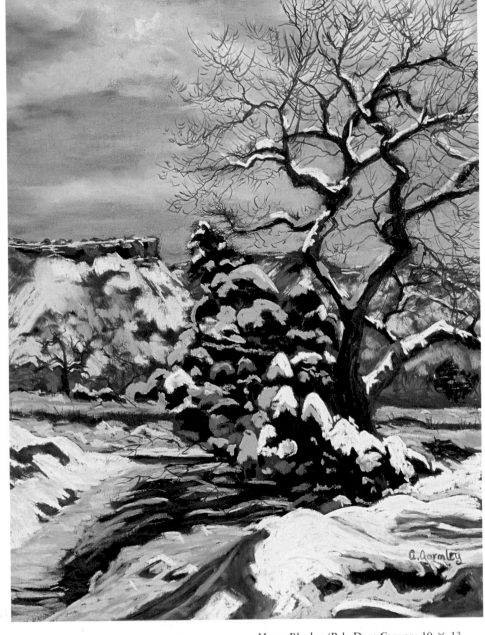

Heavy Blanket (Palo Duro Canyon; 10 × 13
inches, collection of Puckett Elementary School,
Amarillo).

Yellow House Snowscape (Yellow House
Canyon; Pentax 645, 2¼, Kodachrome 64).

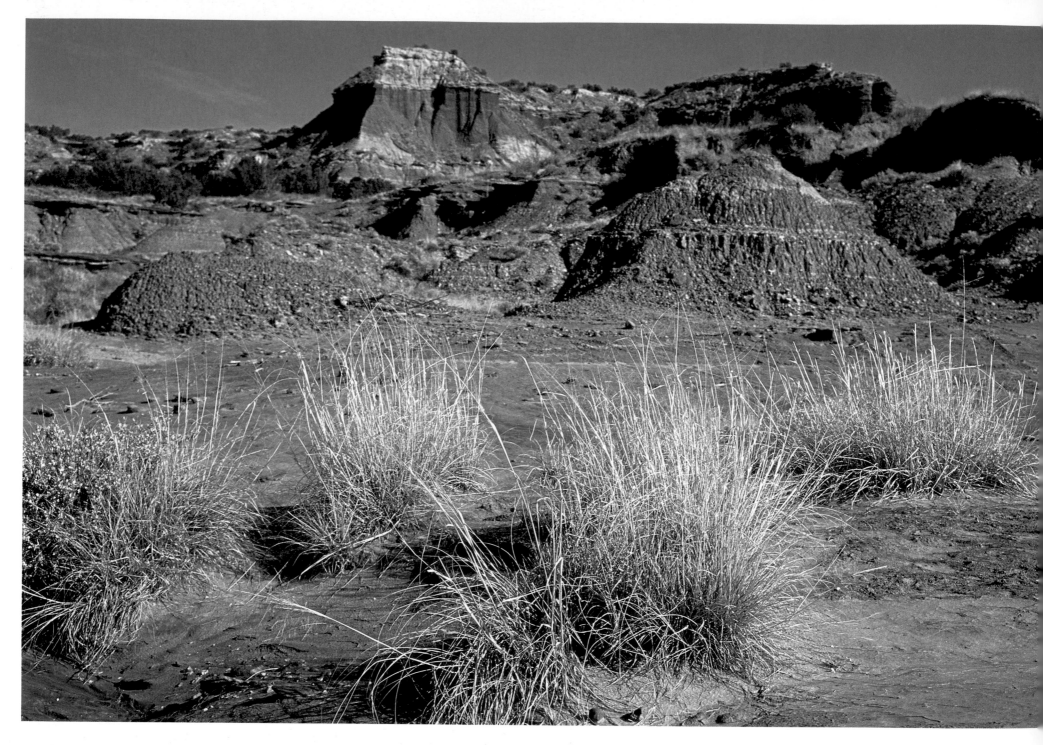

The fine wisps of grassy clumps
growing in canyon badlands and from
austere canyon walls are reminders that
the seemingly fragile can survive and
be beautiful against all odds.

Double Mountain Badlands (Double Mountain
Fork Canyon; Nikon 35mm, Kodachrome 25).

Caprock Nook and Cranny (Caprock Canyons;
12 × 9 inches, collection of Jim Freeman,
Amarillo).

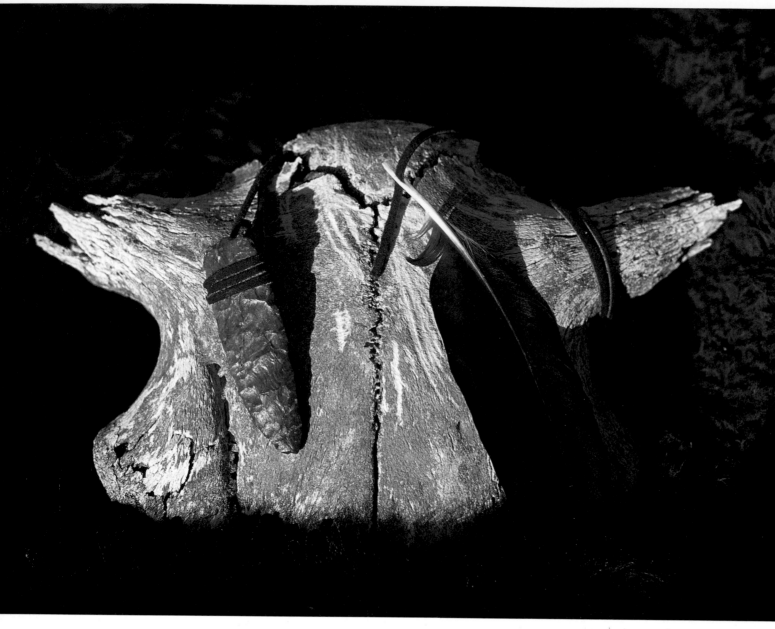

Time and history have texture, too. Comanche petroglyphs on a sandstone face enable us to see ourselves in the context of time, alien things held up for examination by a Native American anthropologist. We moderns look with curiosity and subliminal longing at the sensuous, primal world of the Plains Indians, perhaps because we sense that in the texture of human time here, we are merely a rough bump on a long, smooth slope.

Bison and Point and Raven Feather (Yellow House Canyon; Pentax 645, $2\frac{1}{4}$, Kodachrome 64).

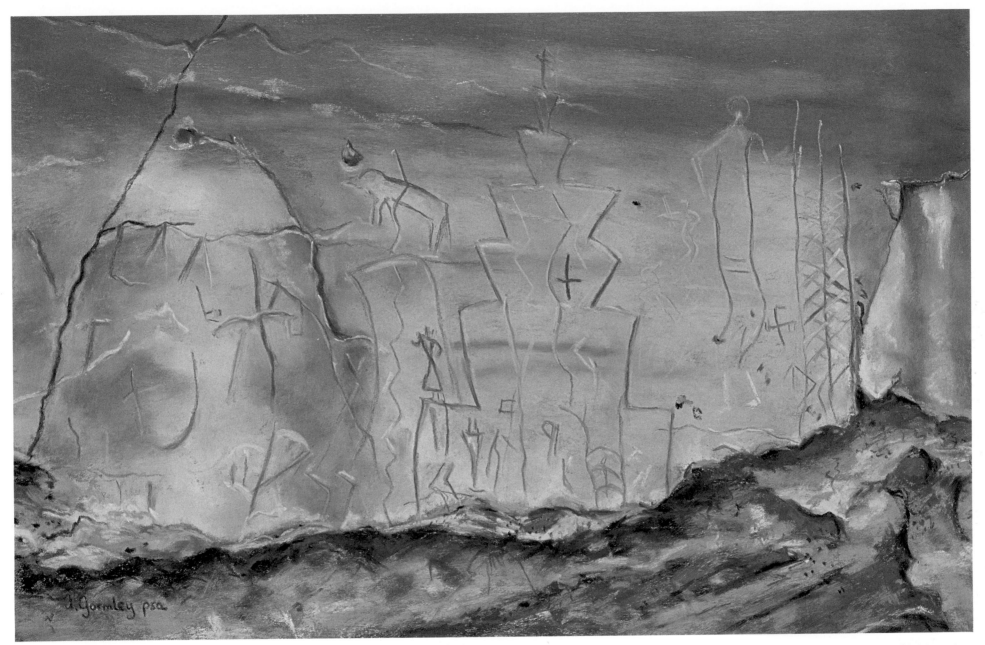

Cowhead Mesa Petroglyphs (Double Mountain Fork Canyon; 8 × 12 inches, collection of Paula Ryan, Amarillo).

COLOR

The canyon wall seems to have had vermillion, yellow ochre and green poured here and there by the hand of a giant and painted in streaks along its face. As the distance grows and the master hand mixes in His blue, the vermillion becomes purple, the yellow a pale green and the trees grow bluer until everything fades away into an opalescent sky.

ALEXANDRE HOGUE
On Palo Duro coloring, 1927

Color is the essential characteristic of painting and an identical twin to composition in artistic photography. It is the clearest vehicle for communicating the artist's wonder at discovering something exciting and alive in the natural landscape. Color never works alone in artistic communication; it connects with line, value, and texture. But it is the strongest communicator of all the artistic elements.

In one combination or another, the primary colors of red, yellow, and blue inform every object. High drama coloring may be difficult to see for those only casually familiar with the Texas plains, but once the eye is exposed to canyonland color, a slow spiral in color awareness begins. Indeed, the subtle colorations of the grassy prairie canyons may make the most powerful impact of all once the viewer's color sensitivity is aroused.

Colors can transmit the mysteries of emotion, relay temperature, create movement, magnify or subtract objects, and even disclose subtleties in their mass content. Van Gogh's letters make specific references to the psychological meanings of the colors he employed, and Beethoven referred to the color associations in sound. Modern research confirms their insights: red and red-orange are emotionally exciting, blue and blue-purple, peaceful; green and yellow-green, tranquil or emotionally neutral; and yellow, cheerful. Artists who use strong primary and secondary colors and their complements in landscapes do so with the expectation of enhancing a viewer's emotional tension, an excitement that ties the viewer to the artist's initial rush of topophilia.

Some landscape art negates regional coloring and abstracts forms beyond recognition. Such is not the intention here; we have tried to capture what we saw. High color may be spotlighted in framing a photograph or used mechanically in a painting to handle atmospheric relationships, perspective, or light reflected and absorbed. But the coloring of the country as portrayed here is no exaggeration. Rather, it is first inspiration, from earth and sky.

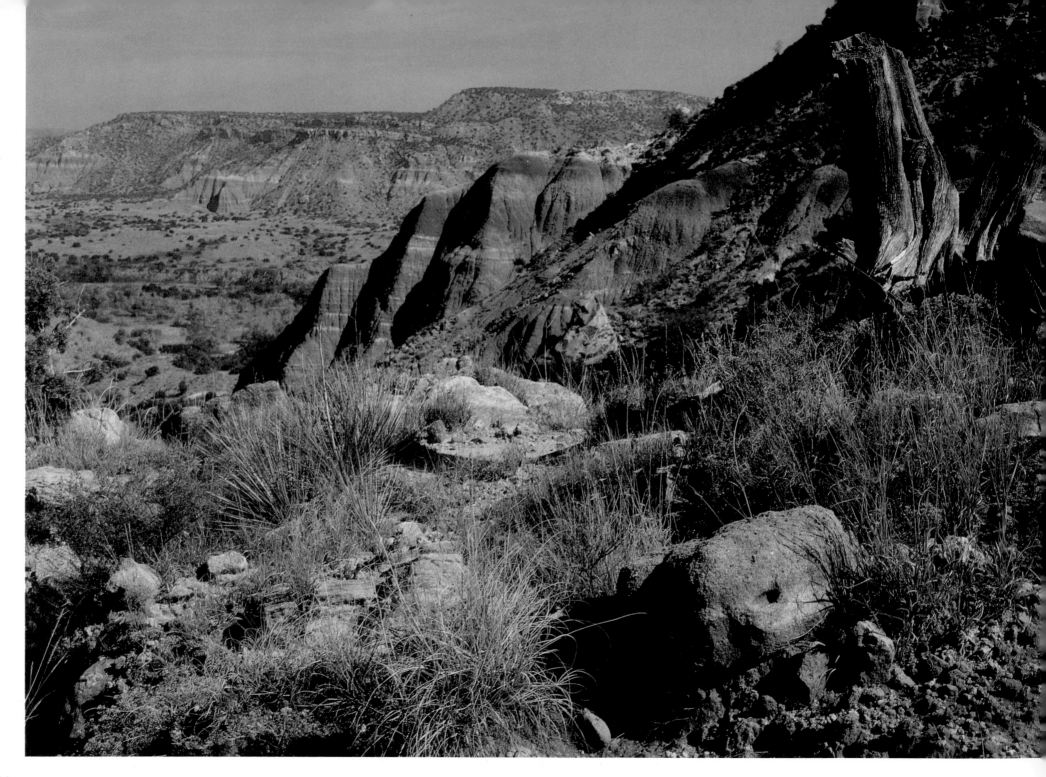

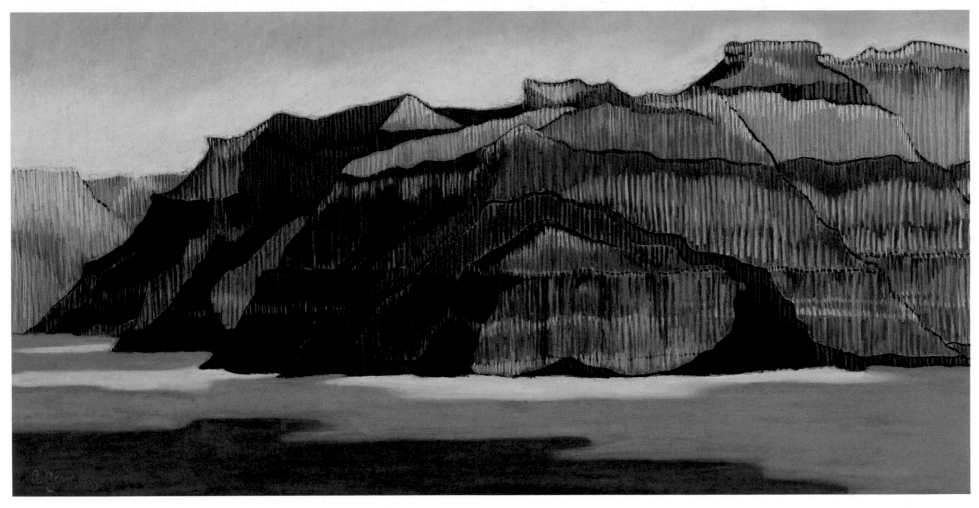

Canyonscape II (Palo Duro Canyon; 12 × 16 inches, collection of Daryl Howard, Austin).

The most elusive scenes to capture well are, paradoxically, the wildest or most dramatic ones. Confronted with a sweeping wilderness overlook or a remarkably vivid canyon wall, the landscapist is compelled to reproduce a powerful sensory effect that is devoid of human artifact, yet rich with human symbolism. When such an image succeeds, it is often because it expresses that duality.

Palo Duro from Indian Point Trail (Confluence, Palo Duro and Cita Canyons; Pentax 645, $2\frac{1}{4}$, Kodachrome 64).

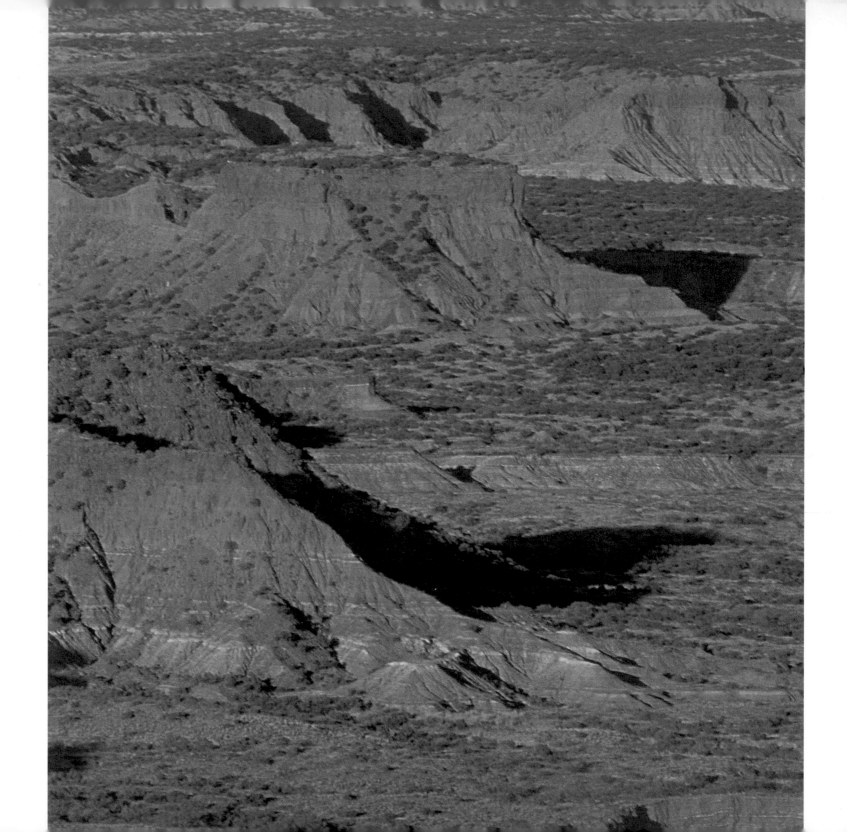

At certain times and in certain places, color energy is as direct a transfer as is possible between rocks and humans. In the strong light of the plains, color ricochets from red sandstone and twangs through green juniper limbs in a virtual energy hologram. The red in Caprock Canyons is as vivid and saturated as the pure red in stained glass. With good reason, an eighteenth-century Spanish explorer gave these sandstone cathedrals the name Sangre de Cristo: nowhere else on the plains is the impact of red so visceral.

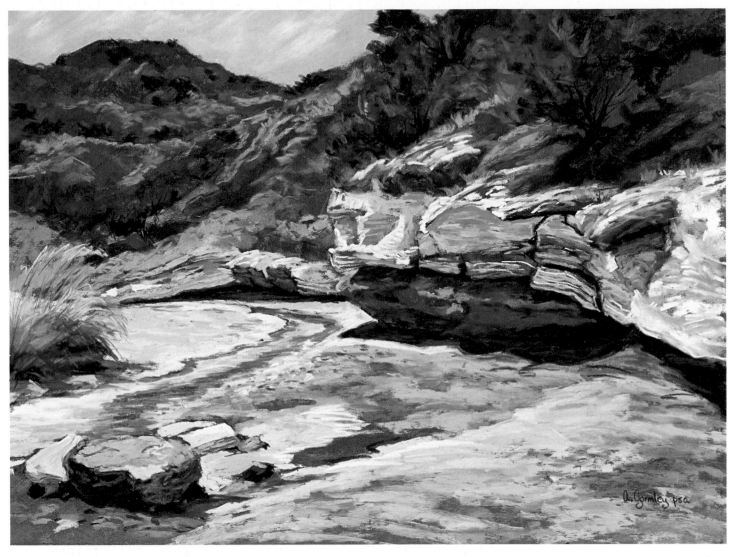

Caprock Canyon (Caprock Canyons; 12 × 16 inches, collection of the artist).

Vermilion Badlands (South Prong Canyon, Caprock Canyons; Mamiya/Sekor 35mm, Kodachrome 64).

Spires, buttes, and chimneys are modern icons of canyonlands country, skeletal remnants whose softer flesh has been sloughed away by water and time to reveal the frame beneath. They stand sentinel along trails and highways like rock lighthouses directing travelers through the malpais ahead, stoic and timeless in their robes of sienna, brown ochre, and carmine. Echoing mauves and crimson, their shadows stretch across flatter ground to emphasize the authority of upright forms.

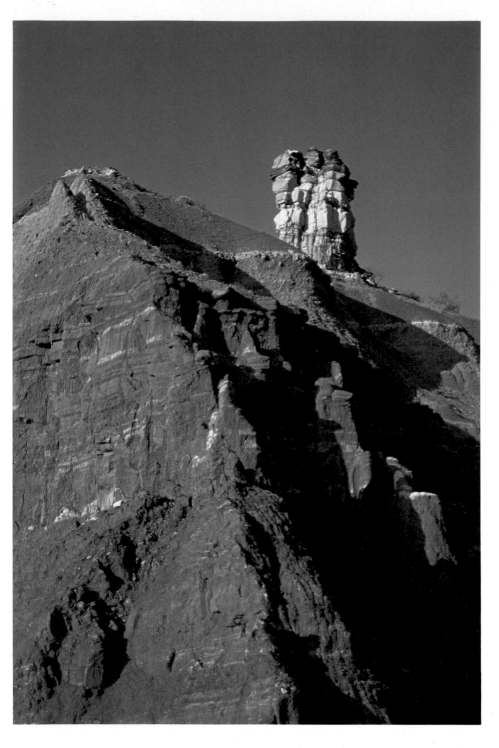

Little Sunday Canyon Chimney (Little Sunday Canyon; Nikon 35mm, Kodachrome 25).

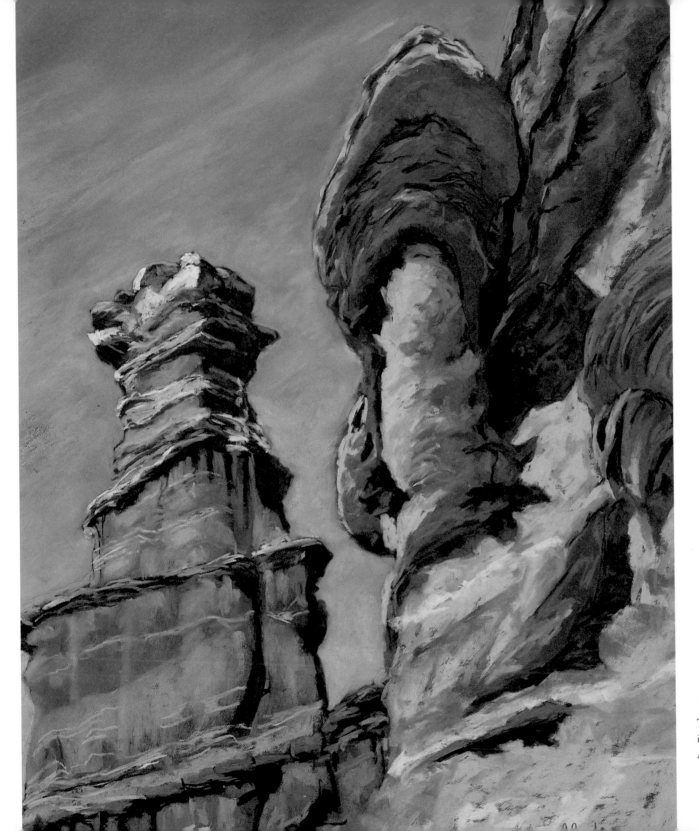

The Lighthouse (Sunday Canyons; 18 × 14 inches, collection of Dr. and Mrs. Chris Brady, Amarillo).

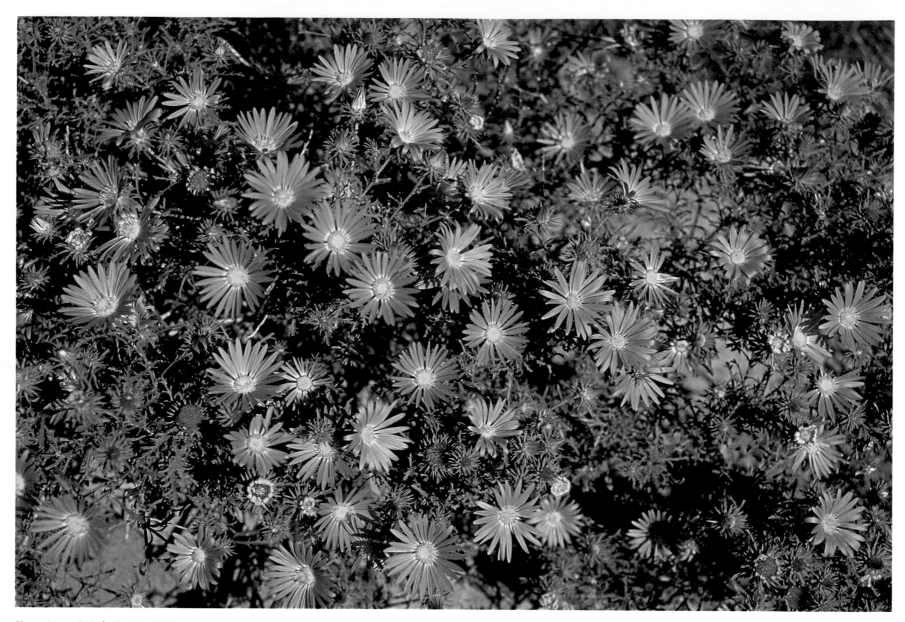

Tansy Asters (Tahoka Daisies) (Quitaque
Canyon; Nikon 35mm, Kodachrome 25).

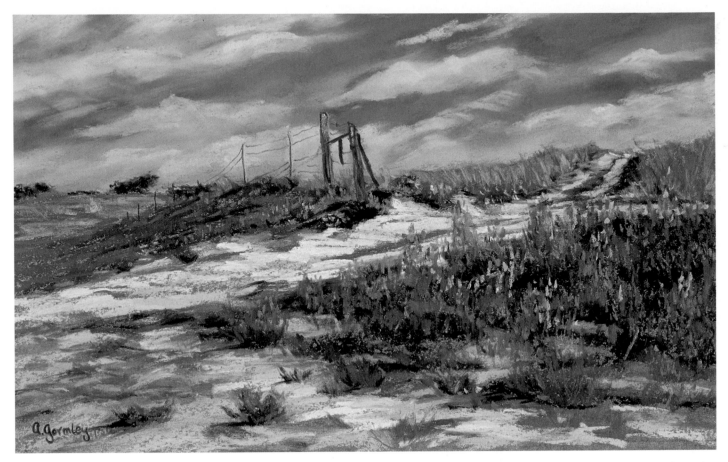

Purple is the color of mystery and hope, a mixture of ultramarine blue and alizarine crimson. Although it is not an unusual color for wildflowers, our reaction is less to its natural democracy than to the exclusivity our culture attaches to it: it is the color of genius, high authority, and royalty. On the Texas plains, royalty is common—often in the poorest of soils—throughout the rough lands.

Purple Run Riot (Palo Duro Canyon; $8\frac{1}{2} \times 14$ inches, collection of Mary Dickgiesser, Stratford, Connecticut).

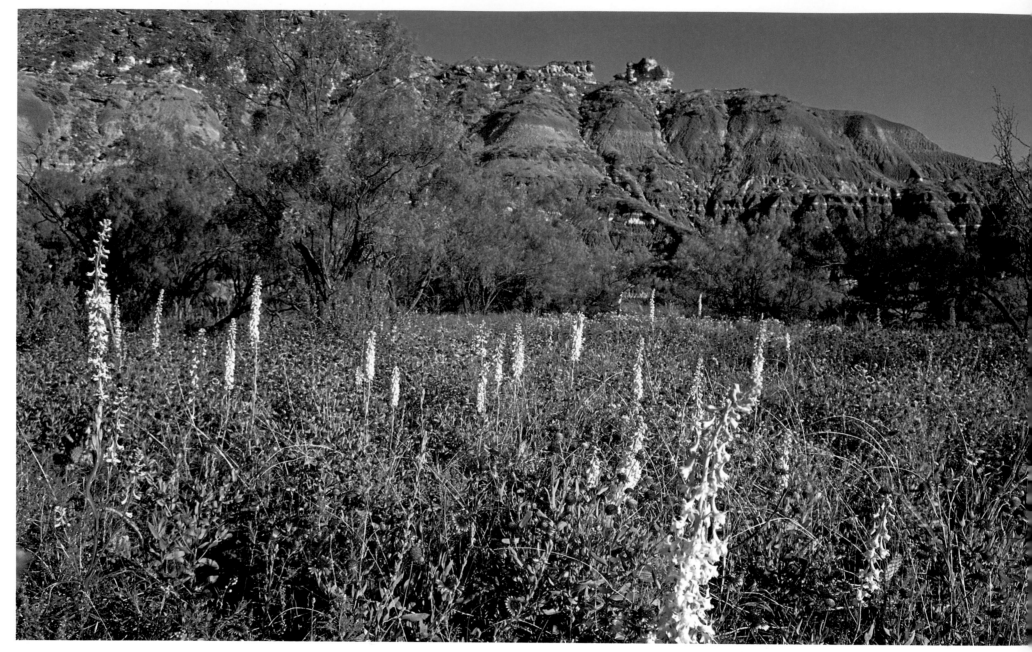

Flowers are thunderbolts at ground level. They demonstrate how color vibrations can be felt on all sensory levels—visual, tactile, olfactory, oral, aural. As entrance into and focus for the dance of seasonal shading, wildflowers invite one to investigate the wider color spectrum of nature.

Spring in Little Sunday Canyon (Little Sunday Canyon; Nikon 35mm, Kodachrome 25).

Late Spring Canyon Bottom (Sunday Canyons; 12 × 18 inches, collection of Ed and Carol Harrell, Claude, Texas).

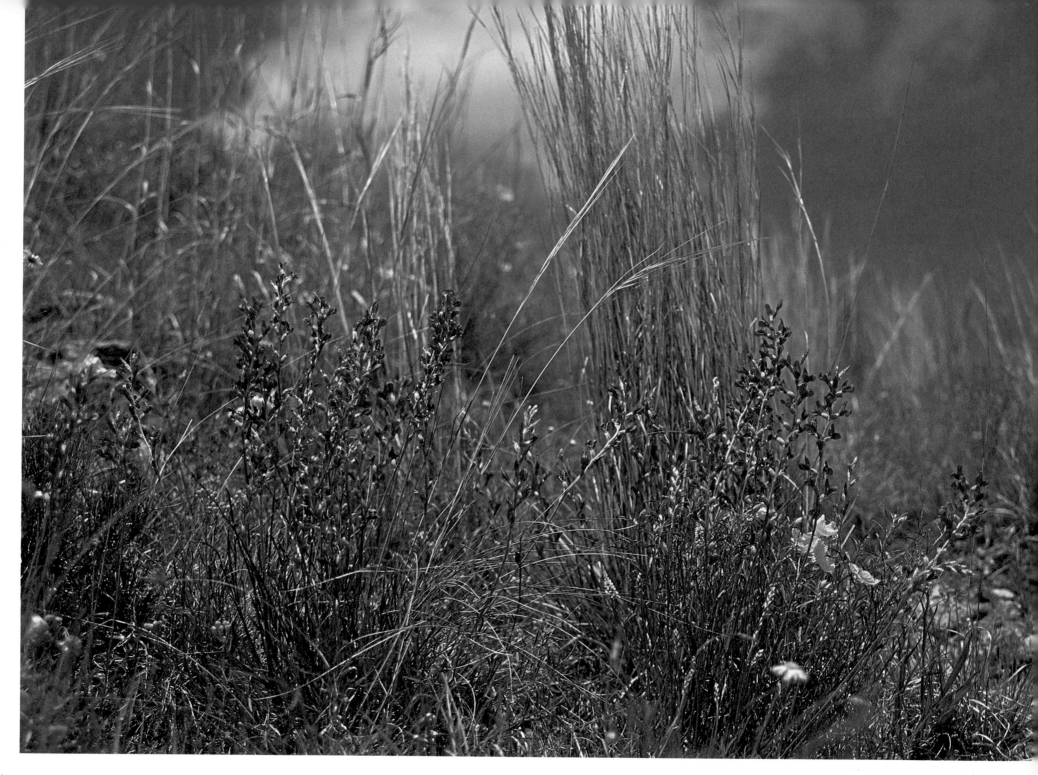

It takes time and familiarity with a landscape before the painter or photographer is able to get beyond the grandeur of the vista and concentrate on the microview at his feet. All the drama and richness of color that exist in panorama are present also in the smaller, seemingly insignificant slices of nature. Being comfortable with the microview is sometimes the key to understanding the intangible scale of vista.

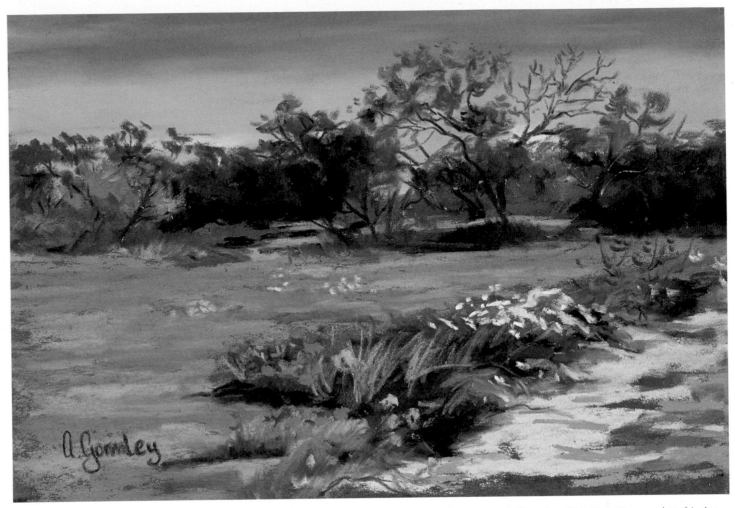

A Short Stop (Palo Duro Canyon; 4 × 6 inches, collection of JoAn Owens, Amarillo).

Locoweed and Zinnias (Yellow House Canyon; Nikon 35mm, Kodachrome 25).

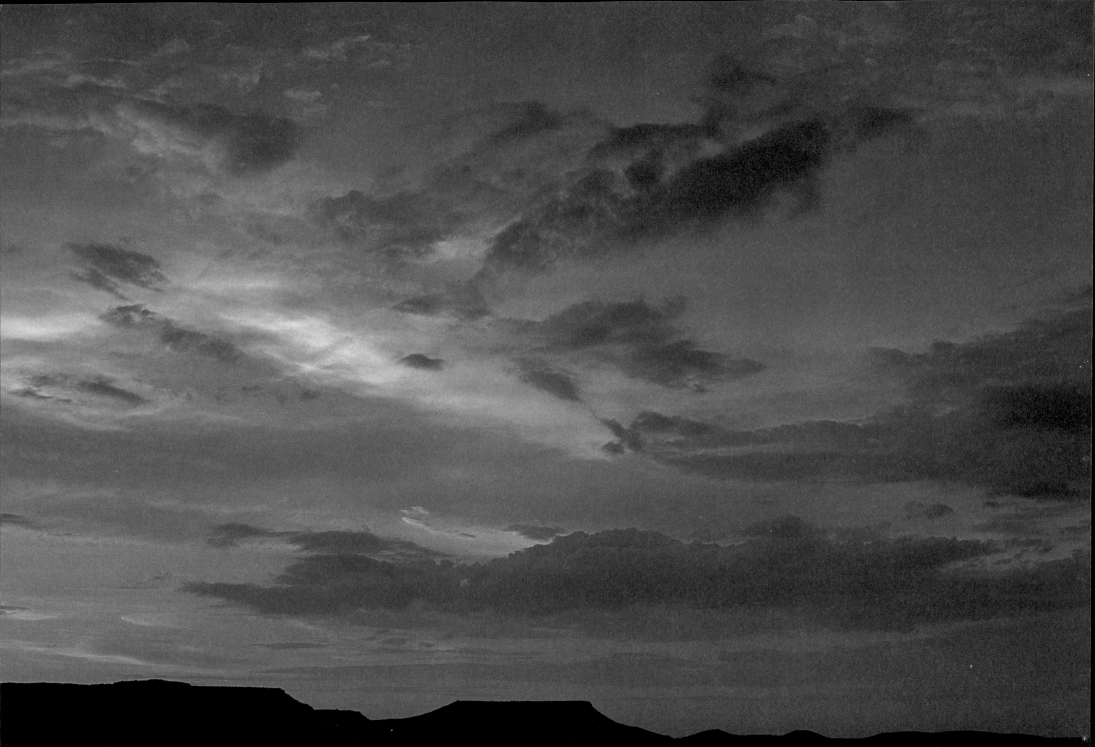

Skies—glowing sunsets, sunrises,
great storm cells, the arching bowl of
cobalt blue—dominate the aesthetic
sensibilities of plains people. The sky is
impossible to ignore in the West simply
because there is so much of it, and
because of the extraordinary range of its
palette.

Falling Mesas Sunset (Yellow House Canyon;
Nikon 35mm, Kodachrome 25).

Summer Sky (Palo Duro Canyon; 16 × 20
inches, collection of Bill and Barbara Haviluk,
St. Louis).

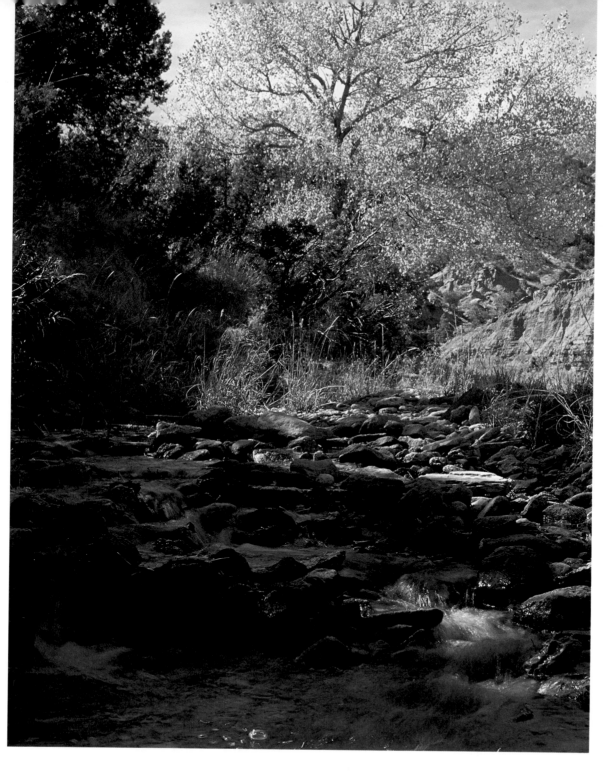

South Cita Autumn (South Cita Canyon; Pentax 645, 2¼, Kodachrome 64).

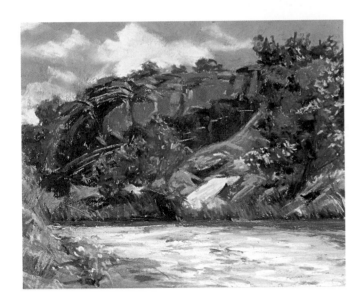

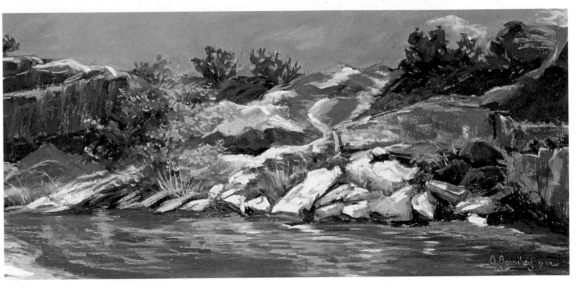

Wading the Red (Palo Duro Canyon; 7 × 9 inches—7 × 15 inches, collection of the artist).

"At long intervals are found, at the head of some side cañon leading up from the main stream, little rills gushing out from near the summit of the plain, hundreds of feet above, looking like little mountain brooks as they descend, tumbling over rocks in mimic falls, with the water all fresh and sparkling."

CHARLES A. H. MCCAULEY
Ornithologist exploring the Red River
canyonlands, 1876

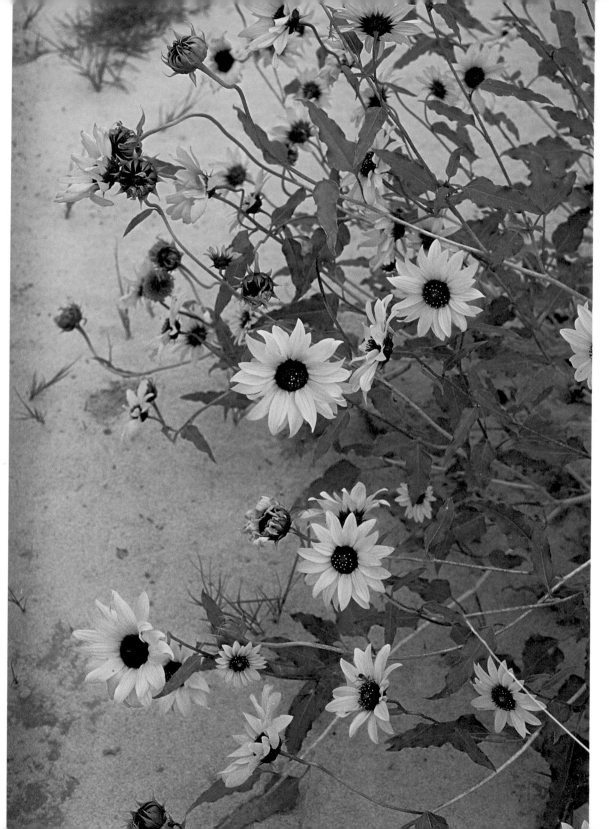

"A simple white drapery, then masses of flowers, sunflowers which [Van Gogh] loved so much. . . . That was his favorite color, if you remember, symbol of the light of which he dreamt in hearts as well as in paintings."

EMILE BERNARD
To G. Albert Aurier, 1890

October Sunflowers (Lower Tule Canyon; Pentax 35mm, Ektachrome 64).

Caliche Dependent (Palo Duro Canyon; 12 × 16 inches, collection of Larry and Judy Paulk, Amarillo).

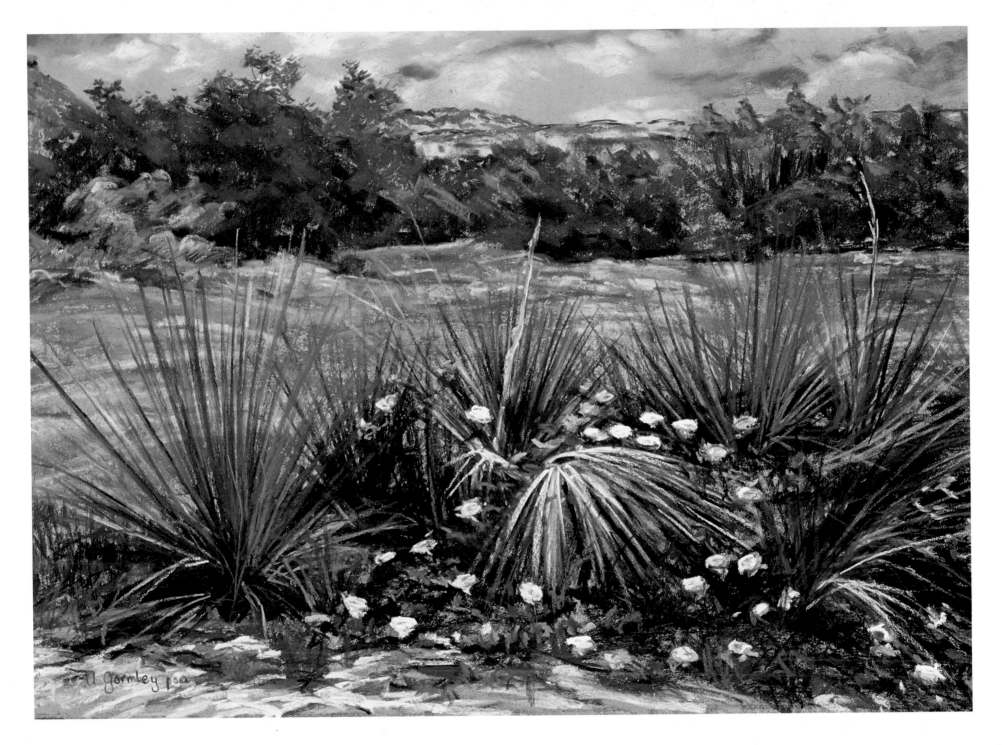

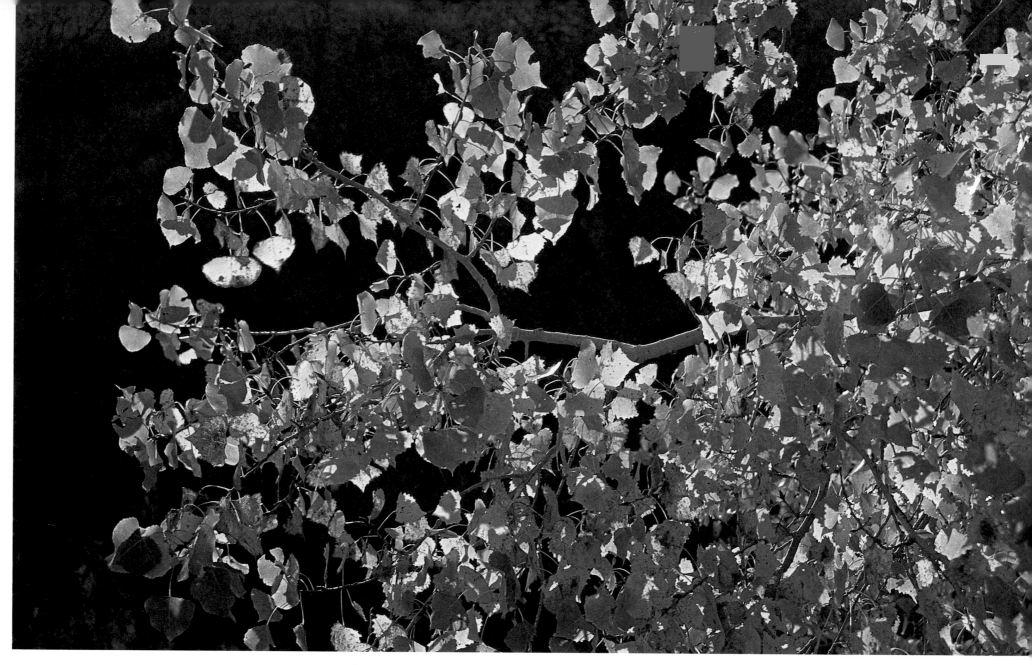

October in the depths of the Llano Estacado. Cottonwood leaves, rustling golden like ten thousand Geisha fans, entertain soaring redtail hawks in mauve canyon amphitheatres. There is a snap in the early morning air, and the light is so intensely yellow that one can almost catch it in the hand.

Late October Cottonwoods (Yellow House Canyon; Nikon 35mm, Kodachrome 25).

Canyon Colors (Palo Duro Canyon; 12 × 16 inches, collection of Daryl Howard, Austin).

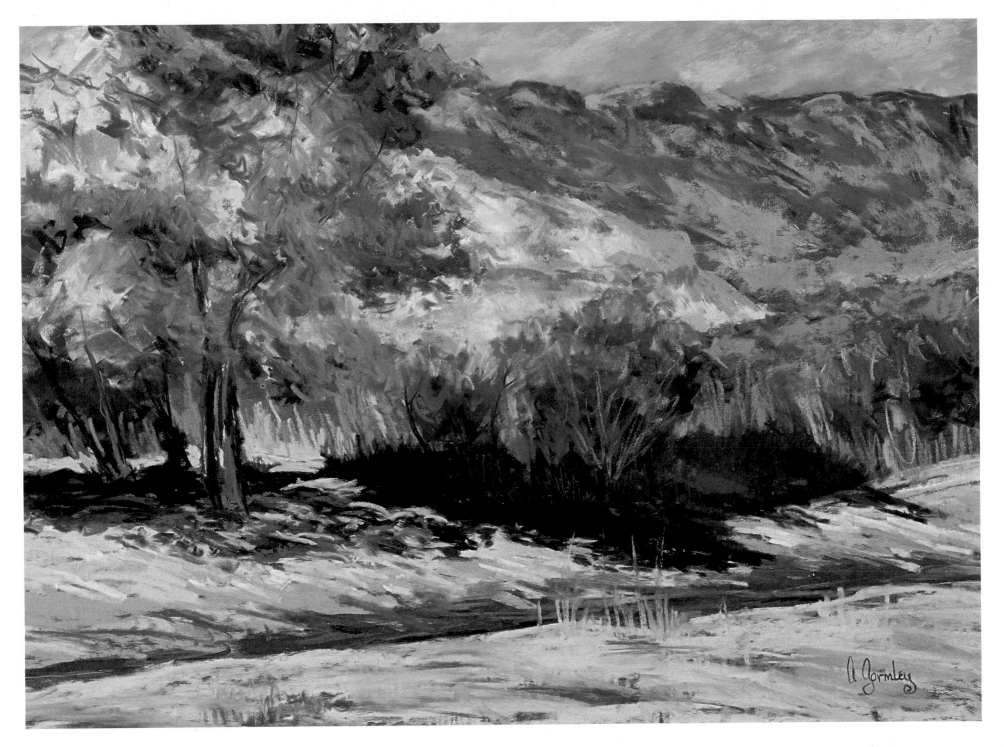

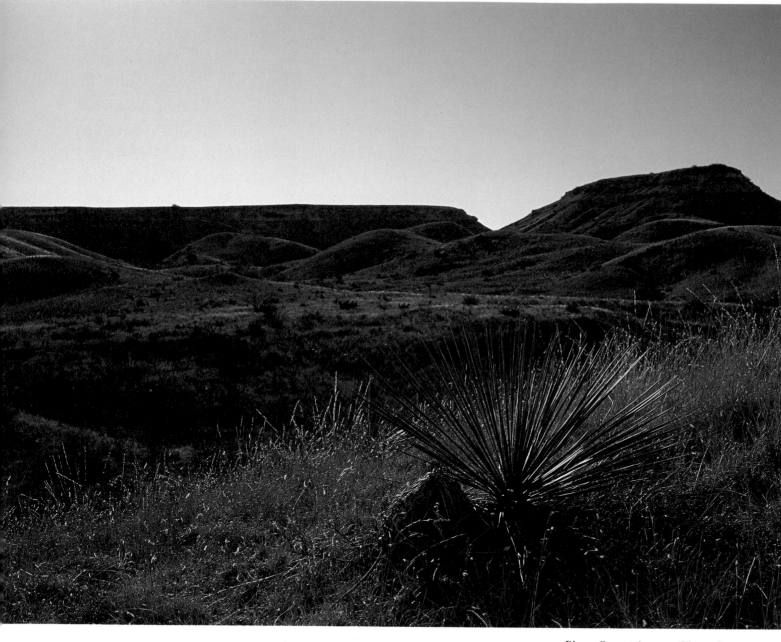

Nature's last strokes of color before winter's sleep ignite the plains landscape in autumn. In grassland canyons, the sere fall coloring is orange, fawn, and yellow ochre, a subtle mix that those unfamiliar with plains and prairie country are apt to miss at first exposure.

Blanco Canyon Autumn (Blanco Canyon; Pentax 645, $2\frac{1}{4}$, Kodachrome 64).

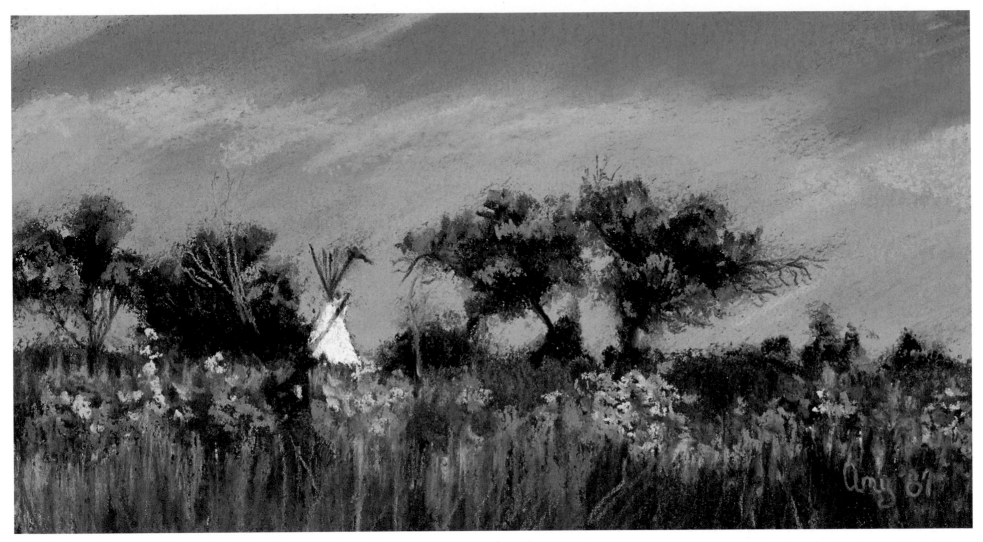

Jim's Lodge (Palo Duro Canyon; 4 × 7 inches, collection of Jim Pfluger, Canyon, Texas).

LIGHT

A ride of six miles, brought us to a precipice bounding this plain on the east, and with a sheer descent to the plain below of six hundred feet. The view was the most extensive and glowing in the sunset, the most striking that we had enjoyed during our whole trip, combining the grandeur of immense space . . . with the beauty of the contrast between the golden carpet of buffalo grass and the pale green of the mesquite tree dotting its surface.

<div align="right">

W. B. PARKER
Exploring the headwaters
of the Brazos, 1854

</div>

To define light, as science does, as visible electromagnetic radiation with a wavelength between 3900 and 7700 angstroms, is to reduce the magical to the mundane. Since our earliest deep sea ancestors peered through the murkiness at the dance of sunlight on the ocean surface, light has fascinated visual creatures and shaped all terrestrial life.

At some indefinable and indistinct line near the 100th meridian, the gray-white, moisture-filled light of the woodlands of the East gives way to the brittle, transparent, bright light of the American West. Early American landscape artists recognized the difference immediately. For Albert Bierstadt, Western light and color created the atmosphere of Italy. Nineteenth-century photographers such as Timothy O'Sullivan, W. H. Jackson, and Eadweard Muybridge did

fascinating studies of light and shadow in the West. It was the light of the Texas plains, more than anything else, that prompted W. B. Parker to express his "wonder . . . that so few if any of our artists ever join expeditions to the plains. . . . Let but the experiment be tried, and prairie scenery will become a valued gem in the gallery." And Georgia O'Keeffe, astonished at her first exposure to Southwestern light, saw Palo Duro Canyon as "a burning, seething cauldron, filled with dramatic light and color."

Light, then—brilliant, transparent, changing, filtered through great distance and with a contrast range far beyond that of even bright days in the East—is at the kernel of the strange and compelling power of the Texas plains.

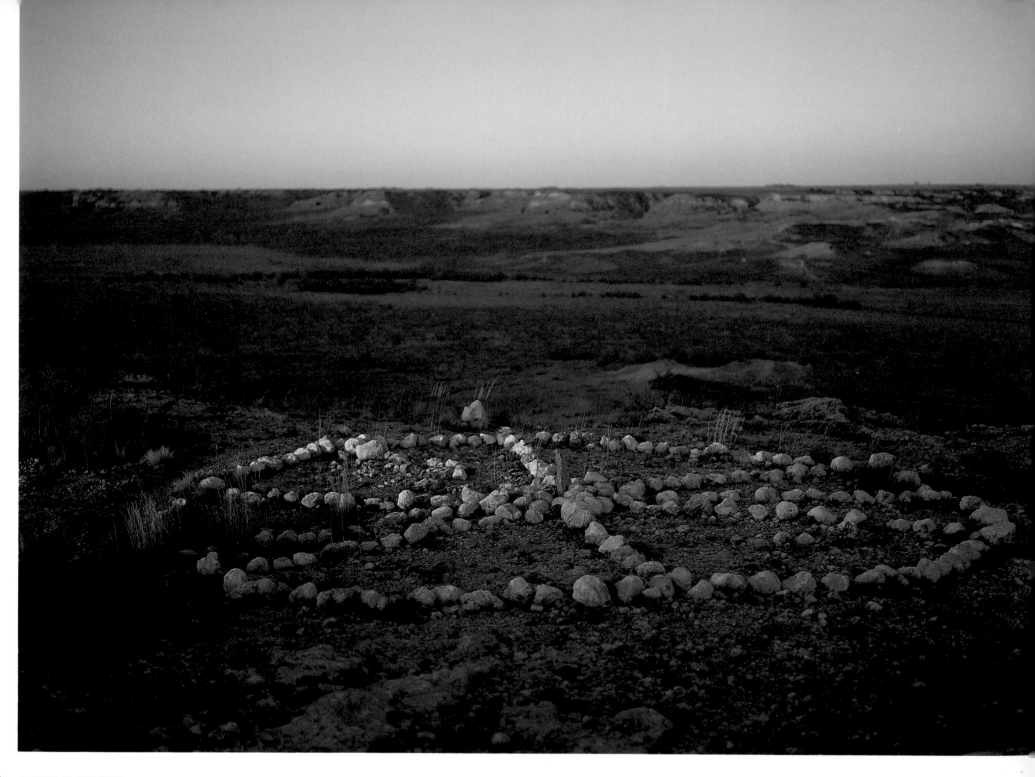

The angles of seasonal light fashion
endlessly evolving tableaux. In the
extended days near the summer solstice,
the light is high and white and long,
and the growing power of the earth is at
its greatest. The low, angling light of
the winter solstice fills the canyons with
shadows and deepens topography so
that every arroyo and wash becomes
more interesting and even mysterious.

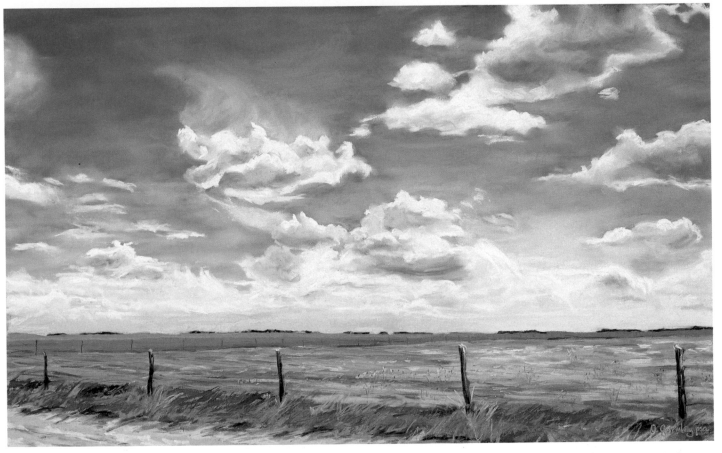

Summer Solstice (Palo Duro Canyon; 12½ × 20
inches, collection of Jim and Loretta Pfluger,
Canyon, Texas).

Winter Solstice Medicine Wheel 1987 (Yellow
House Canyon; Pentax 645, 2¼, Kodachrome 64).

Summer light has a soft, green cast derived from the coloring reflected from growing plants. Shining through pillowy clouds that arrange themselves on a single thermal level and extend to the horizons, sunlight creates contrasts of shadows and light similar to spotlighting on an immense stage.

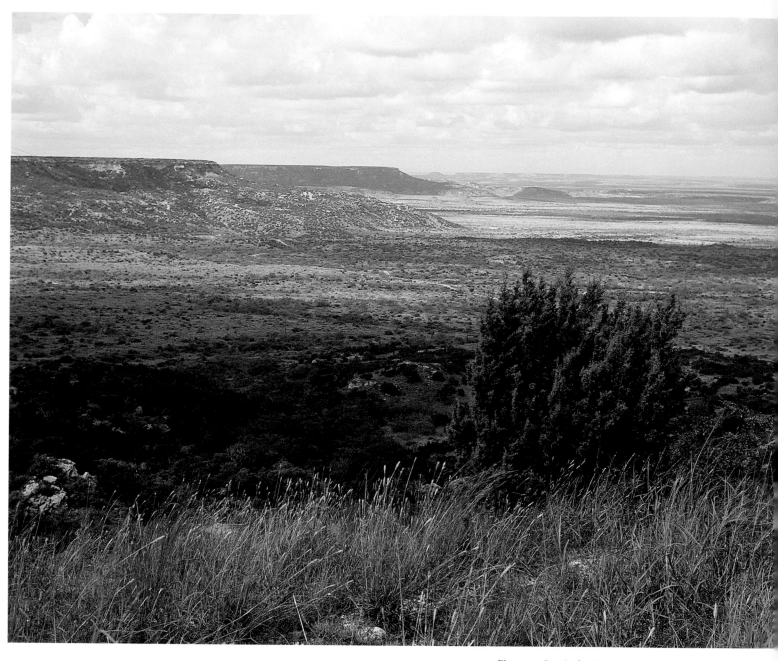

Fluvanna Overlook (Mouth, Double Mountain Fork Canyon; Pentax 645, 2¼, Kodachrome 64).

Double Mountain Fork Afternoon (Double
Mountain Fork Canyon; 7 × 12 inches,
collection of Dr. and Mrs. Patrick Oles,
Amarillo).

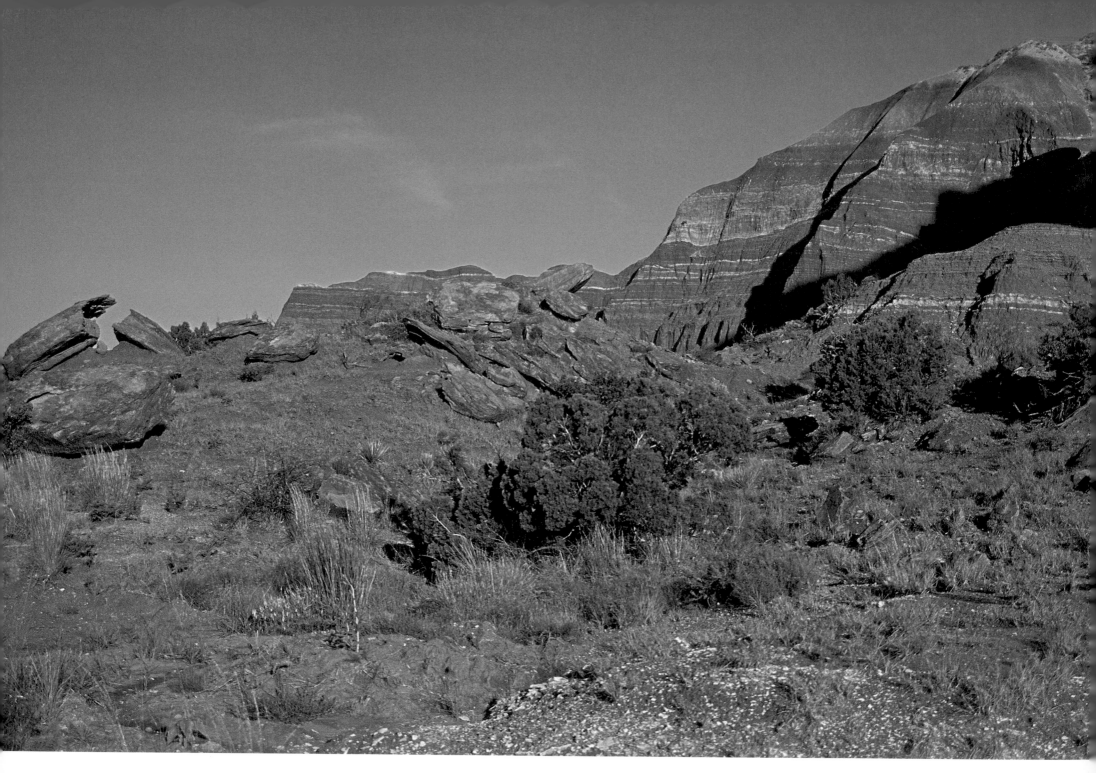

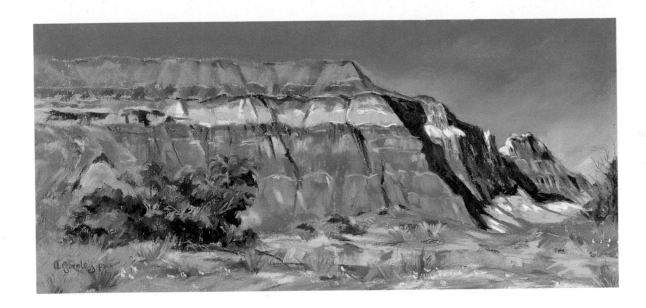

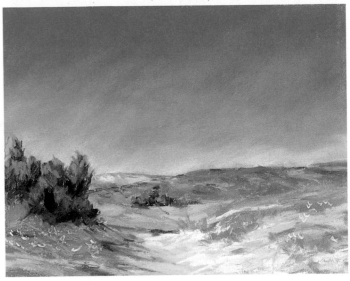

First Tower Gate (Palo Duro Canyon; 7 × 15 inches—7 × 9 inches, collection of Mr. and Mrs. Steve Taylor, Amarillo).

In the Southwest, yellow light is characteristic—of a hue and atmospheric saturation that is never seen in wooded country, and that newcomers to the West find inexplicable. On the plains, it is the melodramatic light when the sun slips beneath a thunderstorm, and the afternoon glow of a grassland autumn. It is also the subtle yellow suffusing whole landforms the morning after a Norther has cleansed and cleared the air.

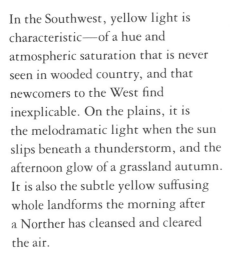

Spanish Skirts, North Cita Canyon (Mouth, North Cita Canyon; Nikon 35mm, Kodachrome 25).

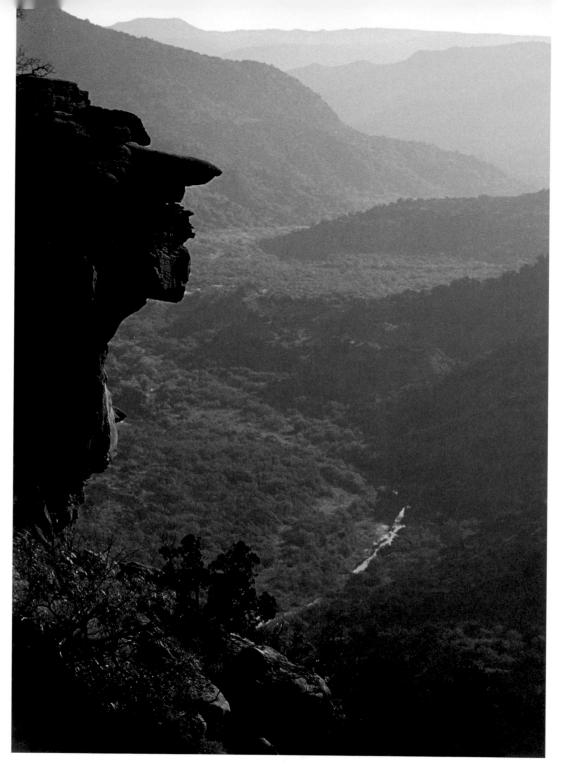

Reflecting from a single dramatic form or filtered through the haze of great distance, light can take on mystical qualities, assume properties detectable by senses beyond the visual. A blue morning in a canyon gorge or a butte standing in meditative silence invite out-of-body journeys through air and light.

Tule Blue Morning (Tule Canyon, east from The Narrows; Pentax 35mm, Ektachrome 100).

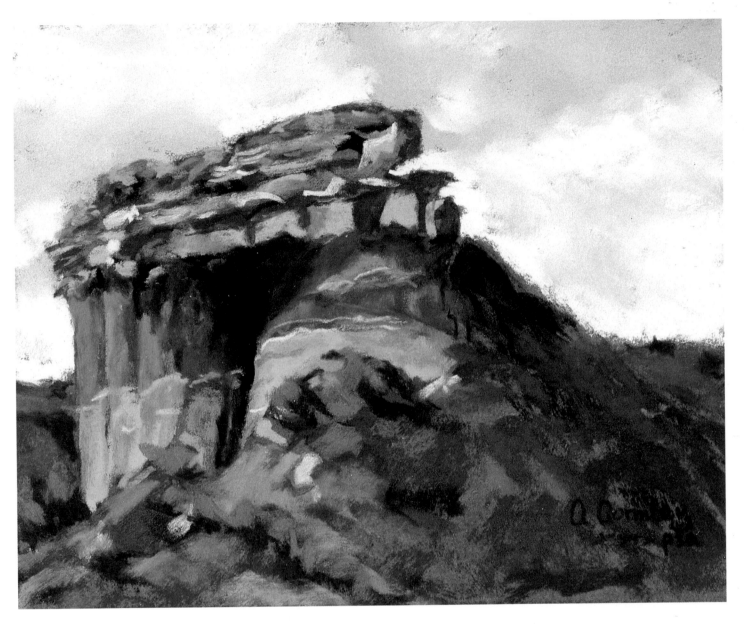

Tule Arc (Tule Canyon; 4 × 5 inches, collection of the artist).

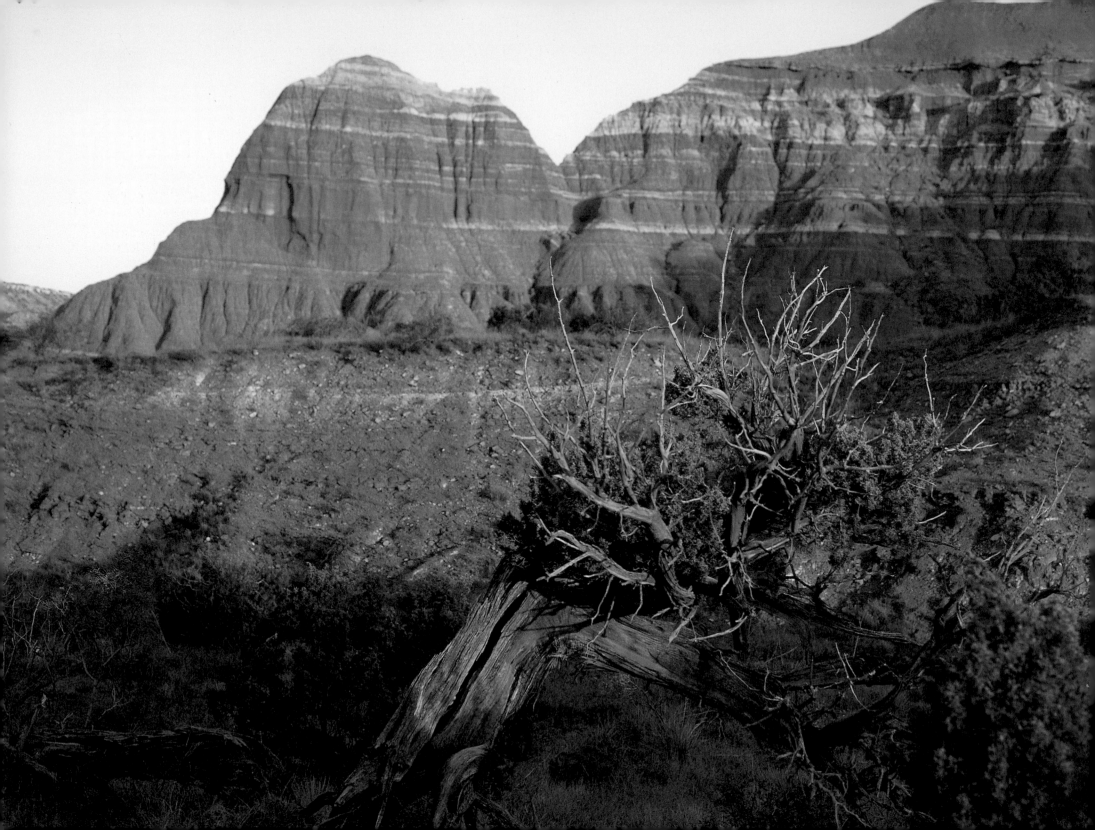

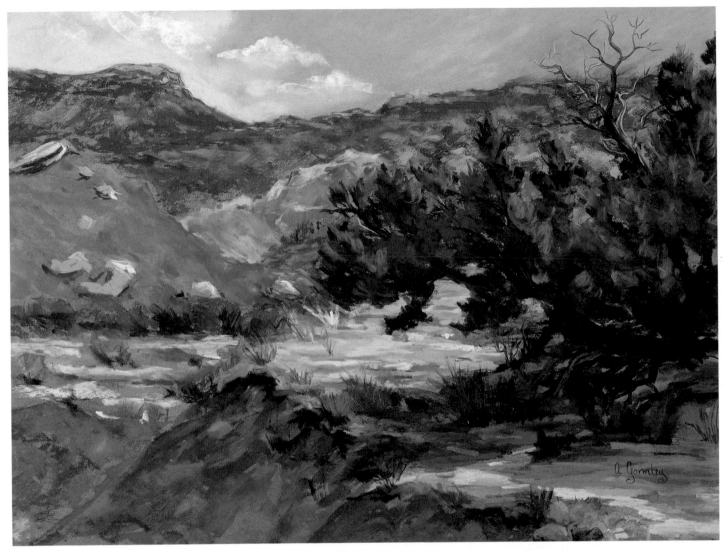

The piquant contrast of juniper shade with the bright light of a midday trail anticipates the elongated shadows and approaching coolness of a canyonland dusk. In the low humidity of the near-desert, sunlight and shade—like day and night—stand thermally farther apart on the scale of relative temperature than they do in other regions.

Canyon Shade (Palo Duro Canyon; 12 × 16 inches, collection of Charles Kitsman, Amarillo).

Palo Duro Dusk (Palo Duro Canyon; Pentax 645, 2¼, Kodachrome 64).

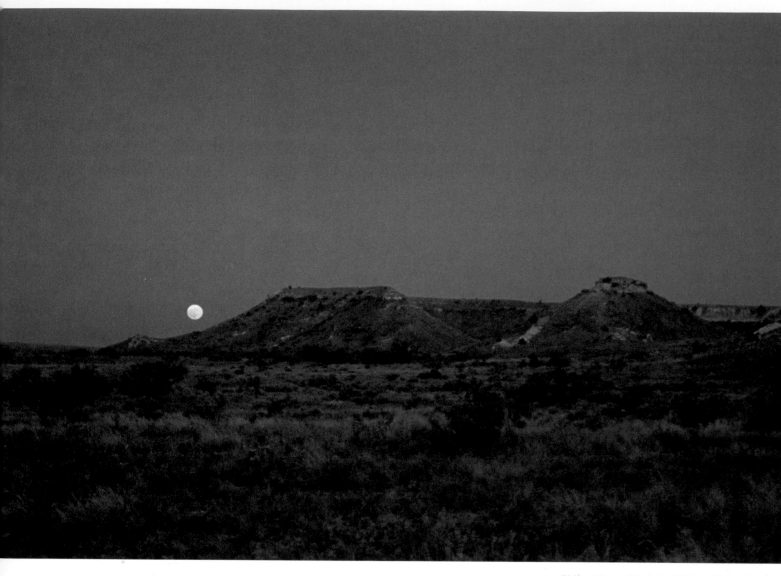

The intersection at which day and night slide into each other rivets us, not just because of extraordinary phenomena such as a harvest moon drifting up from behind the earth or the exquisite play of dawn color around a playa's perimeter, but because our instinctive existentialism would seem reinforced by the miracle of rapid, observable change.

Yellow House Moonrise (Yellow House Canyon; Nikon 35mm, Ektachrome 200).

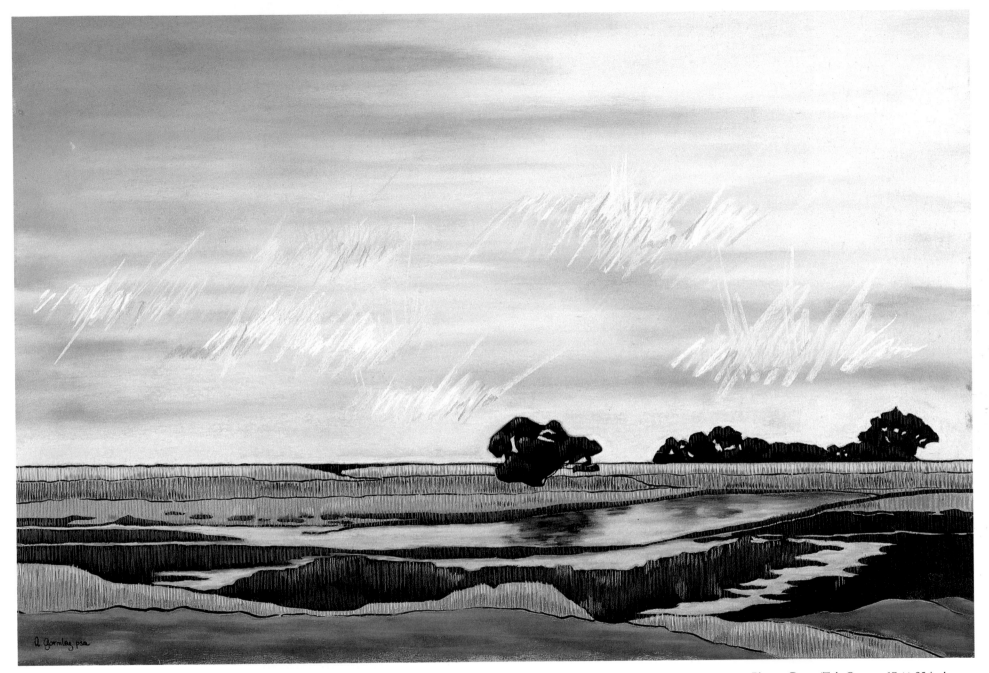

Playa at Dawn (Tule Canyon; 17 × 25 inches, collection of the artist).

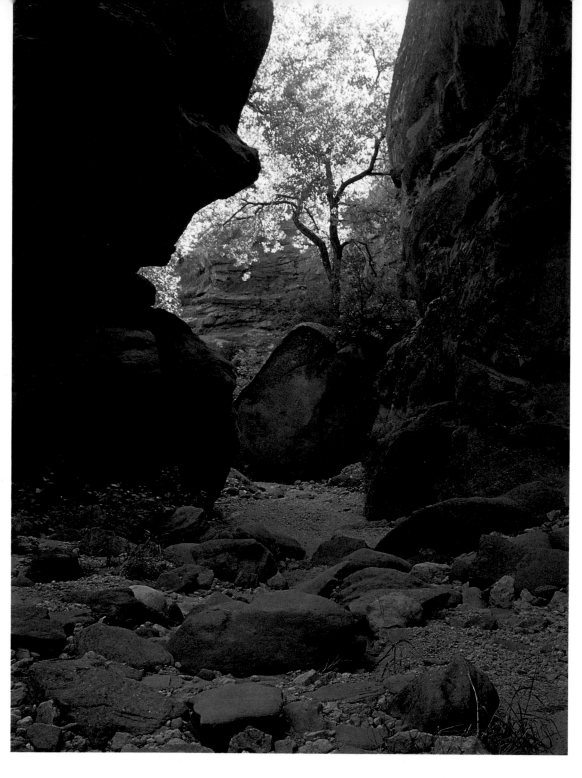

Lingos Narrows (Los Lingos Canyon; Pentax 645, $2\frac{1}{4}$, Kodachrome 64).

Sinuous chutes and corridors are carved out as water interacts with the resistance and give of sandstone and limestone. Whether new and curving or ancient and winding, they create remarkable channels for flowing light and shadow.

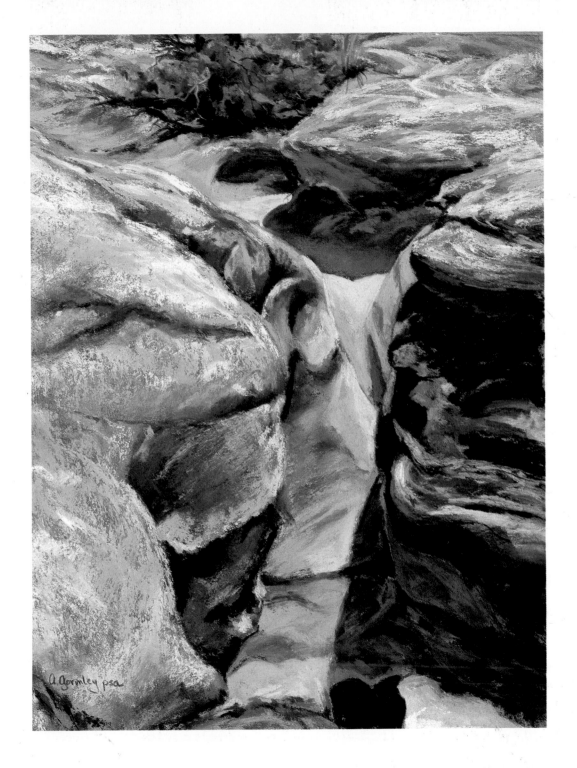

Tule Cut (Tule Canyon; 12 × 9 inches, collection of the artist).

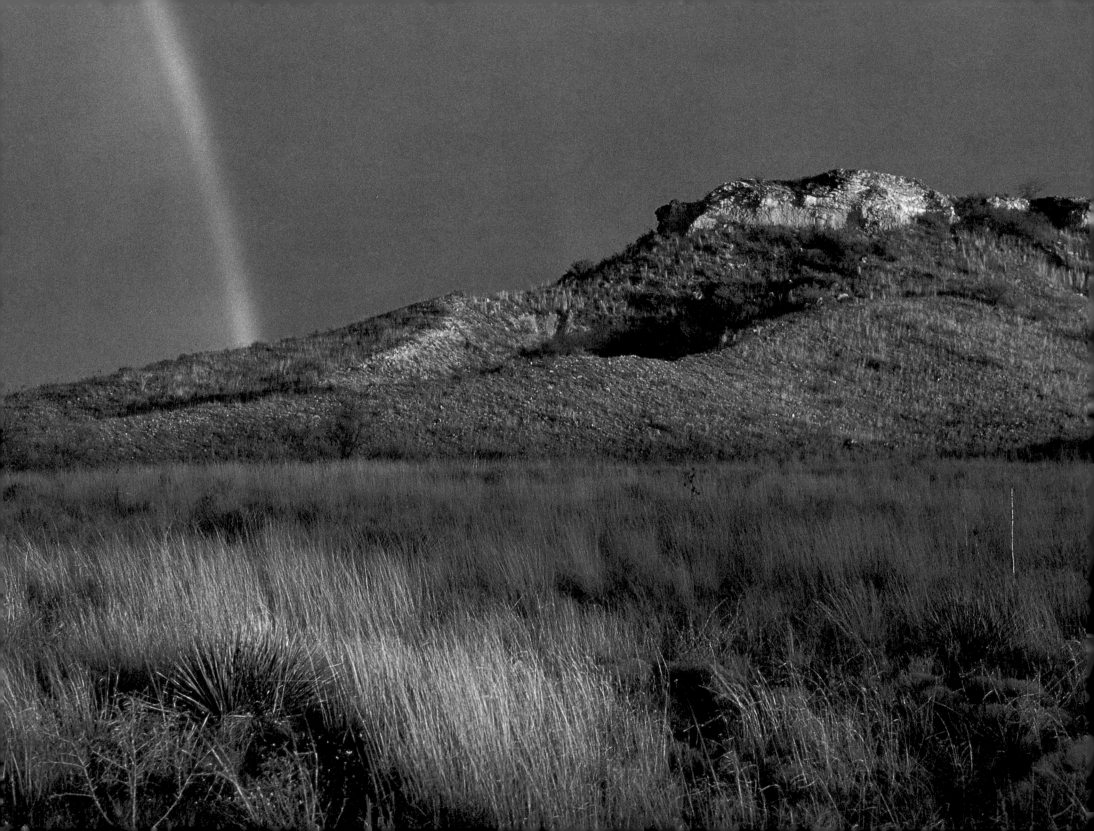

Thunder mutters away into the distance. The summer storm has passed, leaving the country soaked and dripping. Something in the air portends the next act. The transformative energy of a luminous sunset refracted and reflected in hanging mist forms the magical arc, and there are the spectral colors, joining earth and sky in symbiotic covenant.

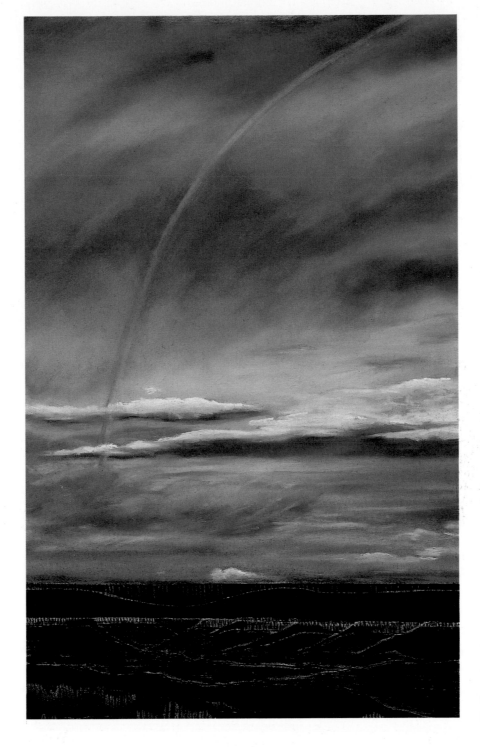

Prairie Rainbow (Yellow House Canyon; Pentax 35mm, Ektachrome 64).

Canyon Covenant (Palo Duro Canyon; 18 × 11 inches, collection of the artist).

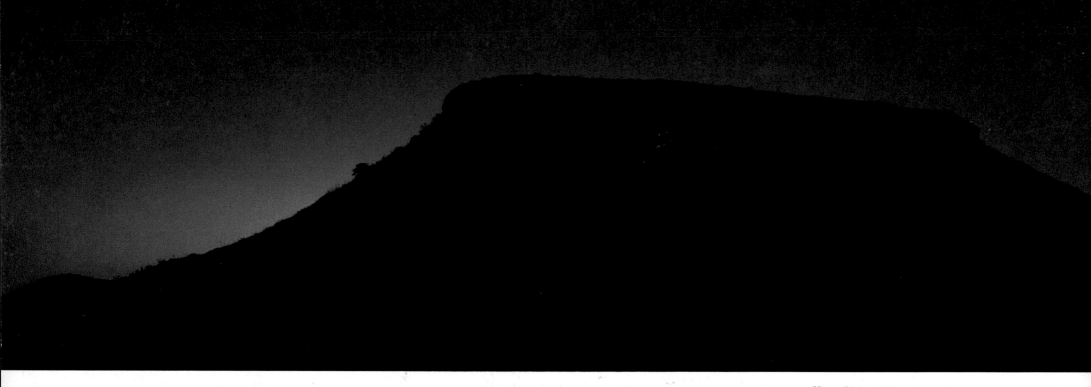

Some of the most memorable images of canyonscapes, prairie spaces, and sky magic are fortuitous encounters between the artistic eye and fleeting visions that are frozen in time by acts of the creative imagination. No belief system holds a monopoly on the sublimity and spirituality that we all sense when confronted with these visions. Perhaps such images are what the Kiowa I-See-O was remembering when he told West Texans in 1924 that "for long, long years it has come back to us in wishes, this great prairie and these beautiful canyons."

Venus Rising (Yellow House Canyon; Pentax 35mm, Kodachrome 64).

The Morning the Sky Was on Fire (Yellow House Canyon; Nikon 35mm, Kodachrome 25).

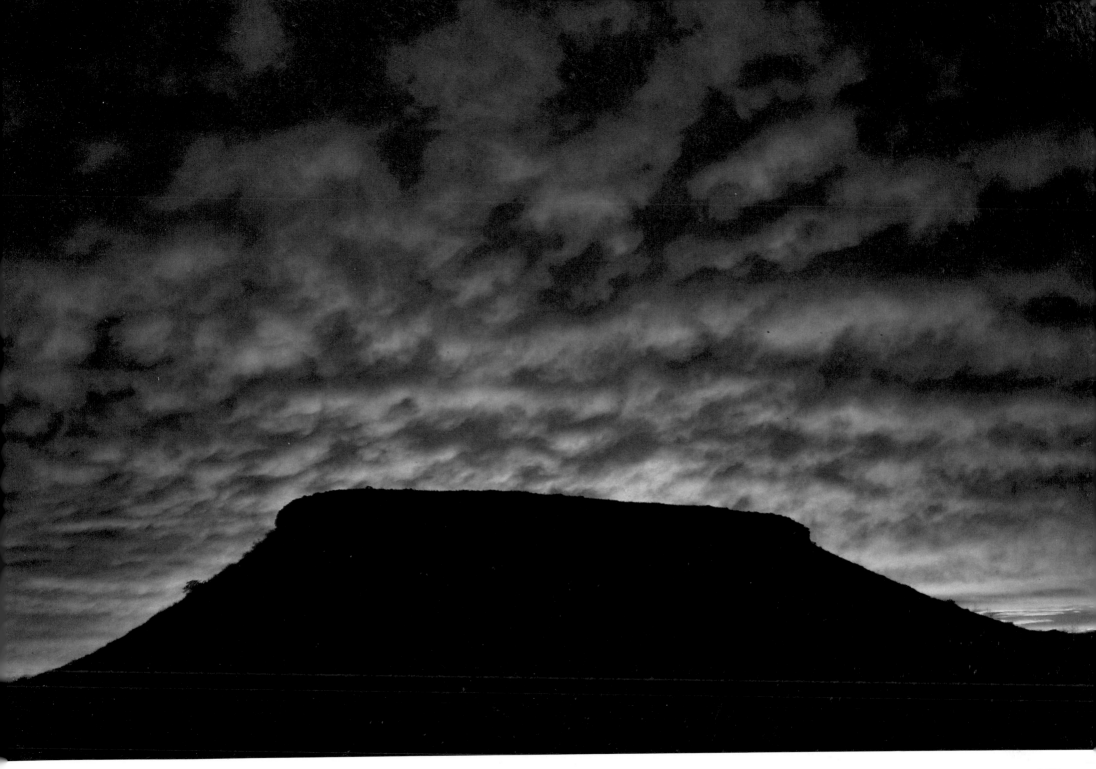

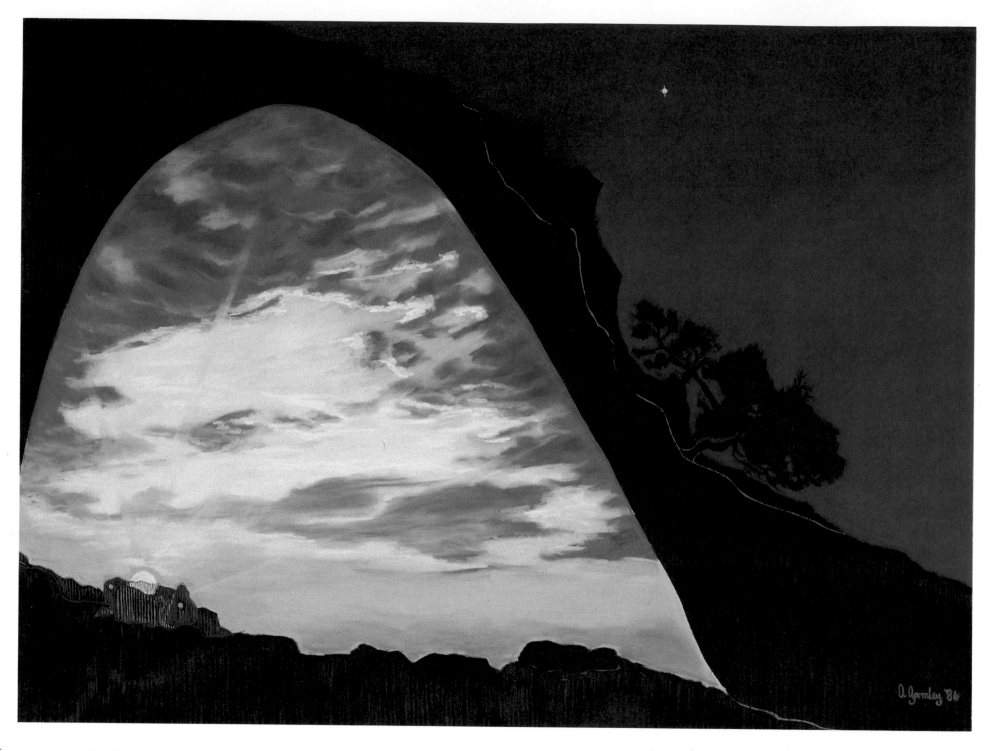

From Darkness into Light (Palo Duro Canyon;
20 × 27 inches, collection of Toni Banks,
Amarillo).

SOURCES OF THE HISTORICAL QUOTATIONS

Page 1 J. Evetts Haley, ed. *Albert Pike's Journeys in the Prairie, 1831–1832*, 23. Canyon, Tex.: Panhandle-Plains Historical Society, 1969.

5 George Wilkins Kendall. *Narrative of the Texan-Santa Fe Expedition*. Facsimile ed. I, 223. 2 vols. Austin: The Steck Co., 1935.

23 Randolph Marcy. *A Report on the Exploration of the Red River, in Louisiana*, 59–60. Washington, D.C.: Government Printing Office, 1854.

32 Ernest H. Ruffner. "Survey of the Headwaters of Red River[,] Tex." *Panhandle-Plains Historical Review* 58 (1985): 11–12.

47 William Shakespeare, *Troilus and Cressida*, Act III, Scene 3.

63 Alexandre Hogue. "Palo Duro: The Paradise of the Panhandle." *Dallas Times-Herald*, 24 July 1927.

79 Charles A. H. McCauley. "Notes on the Ornithology of the Region about the Source of the Red River of Texas." *Panhandle-Plains Historical Review* 59 (1988): 32.

Page 80 Emile Bernard to G. Albert Aurier. In Ronald Pickvance, *Van Gogh in Saint-Remy and Auvers*, 219. New York: Metropolitan Museum and Harry N. Abrams, Inc., 1986.

87 W. B. Parker, *Through Unexplored Texas*, 126, 162–3. Austin: Texas State Historical Association, 1984.

87 Albert Bierstadt to *Crayon* magazine, 1859. In Gordon Hendricks, *Albert Bierstadt: Painter of the American West*, 73. New York: Harry N. Abrams, Inc., 1974.

87 William H. Goetzmann and William N. Goetzmann. *The West of the Imagination*, 423. New York: W. W. Norton, 1986.

104 I-See-O's address to the Amarillo Chamber of Commerce, Amarillo, 1924. Palo Duro Canyon File. Archives, Panhandle-Plains Historical Museum, Canyon, Tex.

INDEXES

CANYONS

Blanco Canyon, 3, 10, 13, 26, 27, 38, 52, 84

Caprock Canyons, 3, 11, 15, 36, 37, 41, 44, 59, 66, 67

Double Mountain Fork Canyon, 30, 34, 35, 54, 58, 61, 90, 91

Los Lingos Canyon, 8, 100

Mulberry Canyon, 49

North Cita Canyon, 92

Palo Duro Canyon, 3, 4, 7, 9, 18, 19, 23, 28, 29, 33, 43, 45, 51, 53, 55, 57, 63, 64, 65, 71, 75, 77, 79, 81, 83, 85, 87, 89, 93, 96, 97, 103, 106, 113

Quitaque Canyon, 12, 70

South Cita Canyons, 78

Sunday Canyons, 68, 69, 72, 73

Tule Canyon, 3, 5, 14, 16, 17, 23, 24, 25, 31, 32, 40, 48, 80, 94, 95, 99, 101

Yellow House Canyon, 4, 6, 20, 21, 38, 39, 42, 50, 56, 60, 74, 76, 82, 88, 98, 102, 104, 105, 113

PASTELS

After the Fire, 21

Below the Spillway, 53

Blanco Canyonscape, 27

Caliche Dependent, 81

Canyon Colors, 83

Canyon Covenant, 103

Canyon Shade, 97

Canyonscape II, 65

Capitol Peak Hoodoo, 33

Caprock Canyon, 67

Caprock Forms, 41

Caprock Nook and Cranny, 59

A Certain Character, 25

Cliffhanger, 43

Cowhead Mesa Petroglyphs, 61

Desert Varnish, 15

Double Mountain Fork Afternoon, 91

Erosion Echoes, 31

First Tower Gate, 93

From Darkness into Light, 106

Galloping Clouds, 7

Heavy Blanket, 57

Jim's Lodge, 85

Late Spring Canyon Bottom, 73
The Lighthouse, 69
Lost Hoodoo, 35
Mulberry Moss, 49
Palo Duro Cave, 29
Plains Prickly Pear, 55
Playa at Dawn, 99
Prairie Dog Fork, 19
Purple Run Riot, 71
Salt Cedars at the Claude Crossing, 51
Seep Spring in the North Prong, 11
A Short Stop, 75
Silver Falls, 13
Spanish Bayonet, 45
Storm Forces, 9
Summer Sky, 77
Summer Solstice, 89
Tule Arc, 95
Tule Cut, 101
Tule Narrows, 17
Twins on the Trail, 37
Wading the Red, 79
Yellow House Canyon, 39

PHOTOGRAPHS

Badlands Hoodoo, 34
Bison and Point and Raven Feather, 60
Blanco Canyon Autumn, 84
Blanco Mounds, 38
Blooming Yucca, 44
Caprock Canyons Mitten, 36
Claude Crossing Erosion Rills, 28
Dance of the Chollas, 54
Double Mountain Badlands, 58
Elemental, 20
Erosion Shadows, 30
Falling Mesas Sunset, 76
Family of Spires, 32
Fluvanna Overlook, 90
Juniper and Moon and Sky, 42
Ke-che-ah-que-hono (Prairie Dog Town River), 18
Late October Cottonwoods, 82
Lingos Falls, 8
Lingos Narrows, 100
Little Sunday Canyon Chimney, 68
Locoweed and Zinnias, 74
Mount Blanco, 26
October Sunflowers, 80

Palo Duro Dusk, 96
Palo Duro from Indian Point Trail, 64
Pools in the Tosah-Honovit, 52
Prairie Rainbow, 102
Quitaque Falls, 12
Reduction Halos, 40
Sensitive Briar Blooms, 50
Shiprock Lichens, 48
Silver Falls Icicles, 10
South Cita Autumn, 78
Spanish Skirts, North Cita Canyon, 92
Spring in Little Sunday Canyon, 72
Storm over Turkey Mesa, 6
Striped Tule Overhang, 14
Tansy Asters (Tahoka Daisies), 70
The Morning the Sky Was on Fire, 105
Tule Blue Morning, 94
Tule Canyon, Eagle's View, 24
Tule Floor, 16
Venus Rising, 104
Vermilion Badlands, 66
Winter Solstice Medicine Wheel, 88
Yellow House Moonrise, 98
Yellow House Snowscape, 56

THE AUTHORS

DAN FLORES is an award-winning writer, a photographer, and a professor of history at Texas Tech University. He has written three books and numerous articles, both popular and scholarly, on the American West, including *Caprock Canyonlands: Journeys into the Heart of the Southern Plains* (forthcoming from the University of Texas Press). A native of Louisiana, he has lived in West Texas since 1978, and homesteads and writes from a twelve-acre place in Yellow House Canyon.

AMY GORMLEY WINTON is a signature member of the Pastel Society of America. Primarily a landscape artist, she has illustrated a book of poetry, was a lecturer of the Texas Cultural Alliance in Mexico, and a teacher to the hearing impaired at the Amarillo Arts Center. Her work is in many private and corporate collections and has been in exhibitions in France, Austria, Mexico, and throughout the United States. Originally from Connecticut, she has lived in Amarillo for fifteen years, and has done much of her work from a studio in Palo Duro Canyon.